Art and Revolution

John Berger

With 71 illustrations and 24 plates

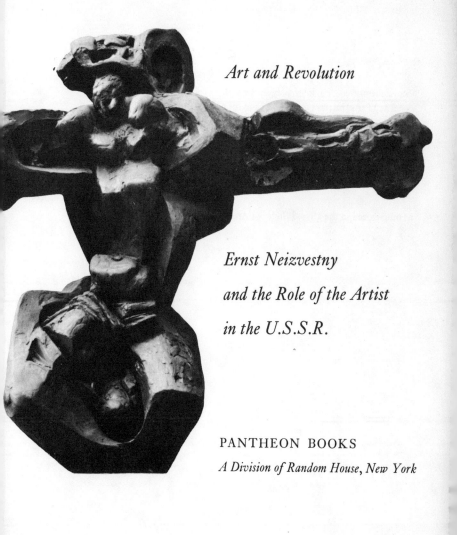

Art and Revolution

Ernst Neizvestny
and the Role of the Artist
in the U.S.S.R.

PANTHEON BOOKS
A Division of Random House, New York

A

To the memory of
I. D.
lucid teacher whom I read
– now silent.

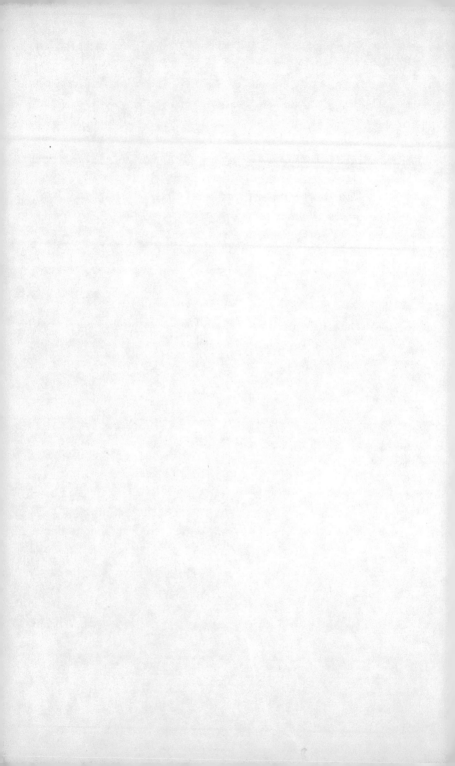

You might ask me as I ask myself why I have spent the last year working on a book about a Russian sculptor whom scarcely anyone outside Russia has heard of. And anyway, you say, how can I, the reader, judge the work of a sculptor solely by photographs, never having seen a single work by him?

Criticism is always a form of intervention: intervention between the work of art and its public. In most cases very little depends upon this intervention. Occasionally, however, criticism can be creative – not so much by virtue of its quality of perception as by virtue of the circumstances upon which it may act. I believe this to be the case in writing now about Ernst Neizvestny. Not to have written this essay would have been a form of cowardice and negligence. Now that it is written I would make quite large claims for it.

By taking and considering in depth a particular example, it throws light on the character of Russian art, the situation of the visual artist today in the U.S.S.R., the meaning of politically revolutionary art and some of the future consequences of revolutionary consciousness. It is of course a short essay and in many directions it only tentatively suggests beginnings . . . but they *are* beginnings, for little else has been written from a similar point of view on these subjects. The essay may have faults and weaknesses, but I would nevertheless put it forward as the best example I have achieved of what I consider to be the critical method.

I wish to make no competitive claim for the importance of Neizvestny's art. Obviously I consider his art important, or I would not have spent a year thinking and writing about it. Yet during that year I have come to see that the arranging of artists in a hierarchy of merit is an idle and essentially dilettante process. What matters are the needs which art answers.

<div align="right">J.B.</div>

*This book could not have been made without the interest and
cooperation of Jean Mohr, who came with us to Moscow and took
many photographs of Neizvestny's work. I would like to thank him
very warmly. I would also like to thank Howard Daniel for
encouragement, help in research, and the loan of innumerable books.*

J.B.

*Other acknowledgements are to:
Sir Kenneth Clark (for illustration on p. 72); Camilla Gray
(illustrations on pp. 40, 41, 43, 45); Eric Estorick, London (illustration
on p. 32); Olaf Forssman, Boras (p. 36); Lund, Humphries & Co.
Ltd (p. 46 – photograph from Gabo); Musée du Louvre (pp. 24, 25);
Musée Rodin, Paris (p. 108); Museum of Modern Art, New York
(p. 34); private collection, U.S.S.R. (p. 46); Russian Museum,
Leningrad (pp. 27, 35, 45); State Tretyakov Gallery, Moscow
(pp. 20, 49, 59); Stedelijk Museum, Amsterdam (p. 33, for illustration
on p. 35). (The works illustrated on pp. 18, 86–93, 107, 123, 125, 151
are in Ernst Neizvestny's own collection, that on p. 80 in the author's.)*

Art and Revolution

1.

The month in which I am writing is June. On the eastern side of the Oder the wild lupins along the side of the main line to Moscow must be growing wildly and the wild acacias must be in full bloom. Trains in that landscape are like ships between small islands far from the mainland.

There are many fir plantations. The trees are planted in straight lines so that as the trains pass – for those who are looking out of the window – there is a strange optical effect as though the corridors between the trees were the traversing beams of light from an invisible lighthouse.

Do the images of the sea recur because this landscape is so far from the sea?

Often the bordering trees around the plantations are silver birches. From the train their silver trunks look as if they have been painted white to define the border.

The plantations give place to fields of wheat and of potatoes and grazing land, but mostly wheat. The wheat is high enough for you to lose your dog in. It is tawny like an animal, but tinged with green and around the skin of its ears with violet.

The sky is very big, the light is stretched across it – stretched so that it gives the impression of having been worn thin. Dog-roses along the railway embankments look like mulberry stains on pale green linen – such is the lack of definition, the endlessness, the edgelessness of the light of the plain.

A woman is watching her cow graze. A couple lie on the pale green linen grass. A cart is drawn by two horses along a straight uneven road. A man bends over some vegetables to see whether they can be picked today. A cyclist appears like a moving post on the far side of the wheat.

The Bug is a smaller river than the Oder. But having crossed it, you are in Russia. People sit in the grass along the

edge of the railway as if it were a river or a canal. The colours of their summer clothes are bright and papery like the colour of bus tickets.

In a street behind the Byelorussian station there is certainly a woman in a white overall and with a kerchief keeping her hair out of her hot face who is selling kvas from a large barrel-like tank on wheels. Kvas is made from black bread and water and yeast, left briefly to ferment together. It is the colour of damp cardboard. Long after you have drunk it, the taste clings to the top of your palate: the taste of bread, summer, the flat plain and the quenching of thirst.

It is the time of year when the courtyards of Moscow lend the city a fourth dimension. There are tens or hundreds of thousands of these courtyards. They are not like gardens or parks.

As two women hang up their washing they talk. There is tall grass around them and against the sky the thick foliage of trees. The earth and dust underfoot is mysteriously of the countryside: like the earth of a well-trodden footpath to a village railway station. The women are dressed like peasants. When one of them has hung up her basketful of washing, she sits down on a wooden bench by a wooden fence and stretches her legs straight out in front of her as though she were on a toboggan.

Around the trees are tall buildings. In one window there is a bird-cage. Regularly the legs of a young girl on a swing obliterate this window. The swing itself is hidden by the trees.

A very thin small man sits on a bench reading. His hands are like a girl's. He wears spectacles. While he reads, holding the book in one hand, he feeds himself with the other. On the bench beside him is a screwed-up piece of newspaper with peas in it. He takes out a pod, slits it with his nail and

puts it to his mouth, like a tiny green flute, so that he can bite the raw peas and eat them. On his other side he makes a neat pile of the empty pods.

When the women stop talking you hear the very light, absolutely echoless and precise sound of a table-tennis ball in fast play. By the swing there are two table-tennis tables. Behind the sound of the ball there is a generalized noise which after a while seems part of the quiet. You are less than 200 yards from the busiest corner of Gorky Street.

*

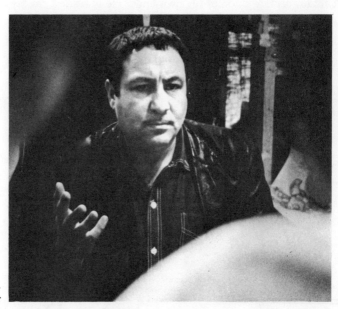

Ernst Neizvestny.
Photo: Mohr

His enemies talk about him as though he were a kind of bandit. Nothing could be further from the truth, but, given their prejudices, the conclusion is understandable. His body is short, broad and bull-like. His hands and arms are clearly very strong. His physical movements look rough because he makes no attempt to qualify or refine them. You

have only to see him tying a shoelace or serving from a dish for delicacy and finesse to become equally obvious. But seen exclusively as an opponent, he appears coarse, defiant, intractable.

Or worse than that, for it is impossible to disregard his intelligence. For his enemies his intelligence is transformed into cunning. And once again his manner can encourage the illusion. He gives the impression of a man driven by deep inner compulsions, who nevertheless misses nothing of what is happening around him. A man who warily but undeviatingly pursues his own ends. He is restless, always moving, always checking. He sleeps little. During his waking life he arrives every few hours at abrupt decisions which immediately force him to interrupt what he is saying or doing. It could easily seem that he is constantly plotting. In fact these sudden changes are the result of ideas proliferating so quickly in his mind that suddenly, unexpectedly, he has to act in order to relieve the pressure.

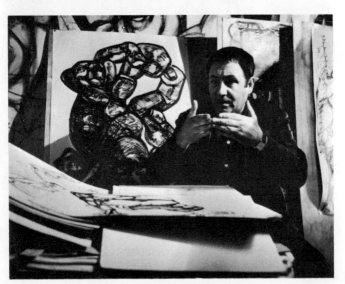

Neizvestny in his workshop. Photo: Mohr

What may, however, disturb his enemies most is the fact that he appears to be so hard to frighten. He is not fearless; no man is. But, as a result of certain experiences which he has continually worked upon in his imagination so that they should never become diluted or disguised, he has remained the familiar of death. And this renders him insensitive to many threats.

Ernst Neizvestny was born in 1926. Neizvestny in Russian means *The Unknown One*. In the first half of the nineteenth century there was a practice of taking very young Jewish boys from their families, baptizing them in the Orthodox Church, giving them new names and training them in military schools and camps in remote parts of the country to be non-commissioned officers in the army. The names given them were often odd or wry: for example Nepomniashchy, meaning *One Who Does Not Remember*. Such was the origin of Neizvestny's name, three generations ago.

Ernst was brought up in the Urals, where his father worked as a doctor and his mother as a scientist. It was an area where there were many exiles both of the anti-communist and communist intelligentsia. The atmosphere of tension, both intellectual and political, made a deep impression upon him.

'My war,' he says, 'began in early childhood and it hasn't stopped. I have always had the feeling of being in the front line. Now I've reached the point where I only feel really well when I'm under stress. But of course today it could be the stress of work . . .'

In 1942 he volunteered for the army, aged sixteen. He became a lieutenant in command of a platoon of commandos. They were dropped behind the German lines. A poem he wrote at that time has the documentary value of a soldier's letter:

Neizvestny. *Soldier Being Bayonetted*. Bronze. 1955

A lull. They fell in clusters.
Fell asleep instantly erased by fatigue.
The living and the corpses embracing.
 In blood.
No disgust. Soon we'll all be dead.

Anyone here? Get up – it's Reveille.
Unfamiliar faces. Blue.
Anyone from the Second Storm
 Battalion still alive?
On your feet. There's fun ahead.

The corpses getting up? How strange.
I thought the living ones were over there . . .

Soon after the night described in this poem, Neizvestny was gravely wounded by a bullet which entered his chest and exploded in his back, and he was left for dead on the ground. Incredibly he survived.

Twenty years later he was awarded the order of the Red Star for his part in that battle. In the intervening years no one had made the connexion between Lieutenant Neizvestny – missing patriot, presumed dead – and a notorious, officially condemned, decadent and 'unpatriotic' sculptor of the same name.

*

In Russia all art up to the beginning of the eighteenth century was Byzantine in style and medieval in spirit. There was no secular art, and religious art was thought of only as an aid to devotion. Oil painting did not exist; the ikons were all painted in tempera on wood. There was virtually no sculpture – only the carving of church furniture, and in the north a certain amount of carved folk art. The tradition had remained fundamentally unchanged for about six centuries. There was no conscious experimentation and

indeed no interest in the ikon as a work of imagination. It was a religious object.

This Russian tradition was further removed from that of Europe than, say, the Chinese. Ancient Chinese art, although also statically traditional, is full of references to the world as perceived through the senses. In the Russian ikon neither space nor time exists. It addresses the eye, but the eye which then shuts in prayer so that the image – now in the mind's eye – is isolated and entirely spiritualized. Yet the images are not introspective – that would already make them too personal; nor are they, in the usual sense of the term, mystical; their calm expressions suggest no exceptional experience.

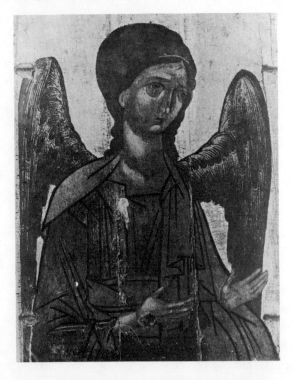

Archangel Michael. Novgorod School. Late fourteenth century

They are images of holy figures seen in the light of a heaven in which the people believe so as to make the visible world around them *credible*. Much later one still finds an understanding of this function of belief in Dostoevsky:

That is why philosophers say that it is impossible to comprehend the essential nature of things on earth. God took seeds from other worlds and sowed them on this earth, and made his garden grow, and everything that could come up came up, but what grows lives and is alive only through the feeling of its contact with other mysterious worlds; if that feeling grows weak or is destroyed in you, then what has grown up in you will also die. Then you will become indifferent to life and even grow to hate it. That is what I think.*

Russian ikons were probably the least contradictory religious pictures ever painted. They were also a profound expression of certain aspects of the national character. Such character, although modified by social change, is not quickly and totally transformed. Vestiges of the 'unworldliness' expressed in the ikon are still to be found in certain Russian attitudes today. This 'unworldliness' should not be sentimentalized; it is so defined only in relation to the 'worldliness' of competitive individualism in bourgeois society.

Today Russian 'unworldliness' has little to do with codified virtue and even less with organized religion. It concerns the value a man puts on his own life. The Russian cannot believe that the meaning of his life is self-sufficient – and therefore that his existence can be pointless. He is inclined to think that his destiny is larger than his interests.

This leads in art to an emphasis on truth and purpose rather than on aesthetic pleasure. Russians expect their

* *The Brothers Karamazov.* Translated by David Magarshack. Penguin Books, 1958.

artists to be prophets – because they think of themselves, they think of all men, as subjects of prophecy.

*

When Peter the Great decided in the eighteenth century to bring the Russia of the ikons into the Europe of Newton, he had to make all his innovations autocratically by decree. For the arts he planned an Academy which, as soon as it was established, controlled all artistic activity in Russia. This Academy was modelled on the French one, founded by Colbert for Louis XIV. That monarch had addressed the members of his Academy as follows: 'I entrust to you the most precious thing on earth – my fame.'

The remark offers us a clue about the nature of academicism in the arts. Academies were and are formed as instruments of the State. Their function is to direct art according to a State policy: not arbitrarily by *Diktat*, but by codifying a system of artistic rules which ensure the continuation of a traditional, homogeneous art reflecting the State ideology. This ideology may be conservative or progressive. But it is intrinsic to all academic systems that theory is isolated from practice. Everything begins and ends with the rules.

This may not at first seem so different from the situation in other periods. Whenever art has served some religious or magical purpose, has it not always been governed by a given set of rules? Of course. But the difference is nevertheless enormous.

When art is an activity of artisans, the rules are intrinsic to the *practice* of working from prototypes. These vary from place to place: as does also the skill of the copiers and the judgement of the masters. Thus there is always room for the particular which may eventually modify the general

rule. Through the opening of the particular can arrive the exceptional, the new.

By contrast the Academy centralizes all artistic activity and regularizes all standards and judgements. (The humbler activities which remain outside its control are dismissed as primitive or 'folk' art.) And the rules, instead of being deduced from particular examples or models at hand, are now induced as abstractions *which schematize and inhibit the artist's imagination before he even begins to work.*

Academicism is an attempt to make art conformist and uniform at a time when, for both social and artistic reasons, it has a natural tendency to be centrifugal and diverse. In certain situations academicism may appear to be progressive but it is always fatal to art.

The Academy in France, although it regularized and stultified most French art for nearly two centuries (the official Salon art of the late nineteenth century was its progeny), was never all-powerful. There were always artists in opposition and artists beyond its pale. In France there was never a single public and market for art; before the Revolution there were both the Court and the middle bourgeoisie; after the Revolution there were the ruling bourgeoisie and a radical intelligentsia in constant opposition. Furthermore, there remained outside the Academy a tradition of realist art. This tradition preserved the principle that art should be concerned with discovery: that is to say with interpreting aspects of reality which up to the present had been ignored, excluded or inadequately treated. The principle, at its purest, had been born with the early Renaissance, but it had been extended by later Flemish and Dutch art. Artists in this tradition recognized the achievements of the past, but their inspiration came from

what had not yet been achieved, from what was not yet art – and this made them profoundly anti-academic. Already in seventeenth-century France there were realist masters – Le Nain, Georges de la Tour, Callot. And it was this tradition which later nourished Chardin, Géricault, Courbet.

Rigaud. Portrait of Louis XIV. 1701

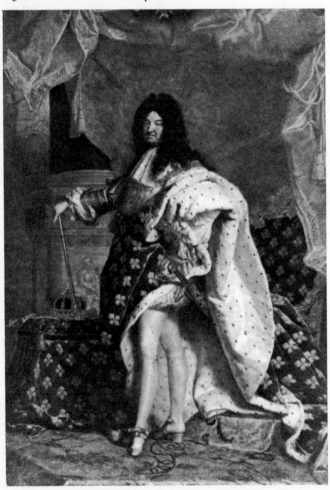

Louis Le Nain. *Le Repos de Paysans.* Approx. 1630s

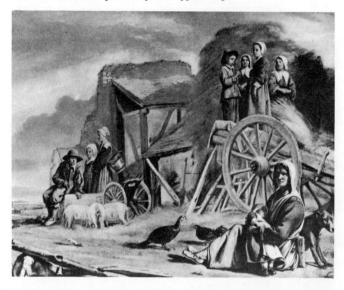

In Russia none of these qualifications applied. The Academy had to create an art public from scratch, and this public, because it was artificially created, remained conformist and ignorant. There was no tradition of realist art. There was no possibility – until late in the nineteenth century – of any alternative patronage to that of the Academy. (Ikon painting continued, but now as an 'inferior', primitive folk art.) Consequently the Academy in Russia was able to conventionalize, inhibit and destroy the potential talent of four or five generations of painters and sculptors.

The schema of rules imposed by the Academy changed with time; neo-classicism gave way to a safe Romanticism, Romanticism degenerated into a kind of anecdotal naturalism. What did not change was the emphasis on theory as distinct from practice. All the Russian artists of the nineteenth century knew *how* they were going to paint before they knew *what* they were going to paint. As a result, their pictures reveal their *choice* of subject, but never the subjects themselves. A subject is revealed in art only when it has forced the artist to adapt his procedure, to admit in terms of his formal means its special case.

When finally in 1863 – two years after the freeing of the serfs – there was the first open revolt against the Academy, it was a political revolt about the choice of subject matter. Thirteen students objected to *The Banquet of the Gods in Valhalla* as the subject of the year's gold medal award, demanding instead a Slav theme. They were expelled, and in order to survive – for they depended upon their academic diplomas for their livelihood – they formed themselves into a kind of guild. From this guild developed the group of artists who called themselves The Wanderers because, by organizing travelling exhibitions of their work, they hoped to reach a popular public in the provinces and rouse its social conscience.

Typical pictures were Repin's *Bargemen* or Yaroshenko's *Everywhere There is Life* – the latter showing convicts in a prison van on their way to Siberia, throwing crumbs to birds through the barred window.

Yet the Wanderers' pictures, whatever the courage of their intentions and however much they were later claimed (under Stalin) as prototypes of revolutionary art, were in fact *painted* in almost the same way as *The Banquet of the Gods in Valhalla* would have been. Having risked a great

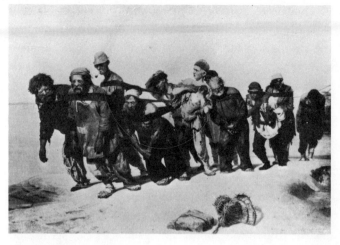

I. E. Repin. *Bargemen.* 1870–73

deal to gain a new freedom, the Wanderers still did not grasp that they were now free to disregard or adapt the theoretical values of their academic tradition. It did not occur to them that the *act* of painting, that the *process* of making representational images could involve any fundamental choices. It was as though they thought of painting as an apparatus which could be used for different purposes, but which could only be operated in one way. Such was the triumph of Russian academicism even over those who, a century after its formation, were utterly opposed to the Academy and the autocratic and absolutist State which it helped to sustain!

*

Russian art radically changed its character after the beginning of the twentieth century. What caused this change?

The liberation of the serfs in 1861 had made a proletariat available for Russian industry. This made the development

of capitalism possible. The power of capital was still seriously restrained by the interests of the landlords and the absolutist State: economic conditions in the countryside prevented the growth of the home market; most of the large industrial enterprises depended upon receiving State orders – for the railways or for the army. Nevertheless a new class of rich industrialists began to emerge, and a few members of this class became the first independent patrons of Russian art. The Wanderers and other artists during the 'seventies and 'eighties were supported by the railway millionaire Savva Mamontov, who set up a 'colony' of artists on his private estate in the country, encouraged research into ancient Russian art and, having gained special permission from the Tsar, set up a private opera in Moscow.

During the 1890s Russian capitalism developed and became more interlocked with Western European capital, particularly French. The style of the new patronage changed accordingly and became more European and more public. The patrons who followed Mamontov financed magazines, arranged international exhibitions and began collecting modern European works – especially from Paris, the capital with which they were already connected by so many financial links.

Outstanding among these new collectors was Sergei Shchukin. In 1897 he bought his first Monet. By 1914 he owned over 200 paintings including important works by Cézanne, Degas, Van Gogh, the Douanier Rousseau, Gauguin, Matisse and Picasso. The Picassos included some of his latest Cubist works. The collection was regularly open to the public and to artists.*

* For further detailed information about the birth of modern art in Russia, see Camilla Gray's pioneering and informative book *The Great Experiment: Russian Art 1863–1922* (Thames & Hudson, 1962).

Thus, for the first time, examples of important contemporary European art, instead of academic theories, were available as a starting point to young Russian artists. At the same time these artists could now *choose* their patrons. The autocratic centralization of the tsars was broken in art before it was broken in politics.

Yet why was the change so radical? Why, for a few years before and after 1917, was there a movement in the Russian visual arts which, for its creativity, confidence, engagement in life and synthesizing power, has so far remained unique in the history of modern art? Why do certain works and ideas, created in Russia between 1917 and 1923, refer to the future in 1968?

Up to 1917 Russia was still politically an absolutist State without democratic liberties. It was still awaiting the transformations which in the other industrialized countries had been brought about by bourgeois revolutions. Yet the Russian bourgeoisie as a whole remained timid, unrevolutionary and only mildly reformist in respect of the autocracy. (The fact that a few unusually intelligent individuals patronized the arts on such a scale and in such a remarkably far-sighted way may be connected with the weakness and lack of vision of the bourgeoisie as a whole; had they been members of a class in which they could believe as a force, they might well have directed their vision and energy into political and financial organization.)

At the same time the Russian proletariat formed in the relatively few (compared to Western Europe) but very large-scale factories and industrial centres, was quickly becoming one of the most militant and revolutionary in Europe. The Revolution of 1905 suggested that the revolutionary force of the workers was overtaking and

out-bidding that of the bourgeoisie *before* the latter had established the necessary conditions for their own proper economic development. Twelve years later the two Revolutions of 1917 proved that this was indeed the case.

At this period Russian artists, as members of the Russian intelligentsia, were, by definition, concerned with the political and spiritual future of their country. The most far-seeing envisaged this future as socialist. They recognized that the autocracy had to be destroyed and none wished to imitate in Russia the ruthless and soulless capitalism of the West. They disagreed about means and particular aims. Some placed their faith in the character of the Russian peasant, others in industrialization, some in permanent revolution, a few in unorthodox religion, but all of them were aware of the strange dynamic of the Russian situation: their backwardness had become the very condition of their seizing a future, far in advance of the rest of Europe. They could transcend the European present, the present of the dehumanized bourgeoisie. Instead of a present, they had a past and a future. Instead of compromises, they had extremes. Instead of limited possibilities, they had open prophecies.

Given this formulation, the interests of the visual artists were exactly as one might expect: an enthusiastic rediscovery of pre-European Russian art coupled with a search for the most advanced, the most modern means of expression.

(It might seem that there was a similar pattern of interest in the West: enthusiasm for the 'primitive' accompanied by sophisticated innovation. But for the West the 'primitive' belonged to foreign, exotic cultures and consequently there was little accompanying sense of continuity and destiny.)

The modern means of expression were supplied by Cubism. For a fuller study of the historical meaning of

Cubism I must refer the reader to what I have written elsewhere.* Here it must suffice to point out that Cubism rejected the way of seeing, the approach to reality which originated in the Renaissance and had continued as the basis of art ever since. Cubism, in other words, marked in its own field the end of precisely that era – the era of capitalism, bourgeois individuality, utilitarianism – which Russia, it seemed, was about to transcend without ever having entered. And it marked it, not nostalgically, but triumphantly by revealing new, more open and more complex possibilities.

Apollinaire wrote in 1914:

> Where then is my youth fallen
> You see the future ablaze
> I speak today you must know
> To tell all the world
> That the art of prophecy is born at last.

In 1921 Malevich wrote: 'Cubism and Futurism were the revolutionary forms in art, foreshadowing the revolution in political and economic life of 1917.'

It was the conjunction of the Cubist example and the revolutionary possibilities in Russia which made the Russian art of this period unique.

*

* 'The Moment of Cubism', *New Left Review*, no. 42, 1967.

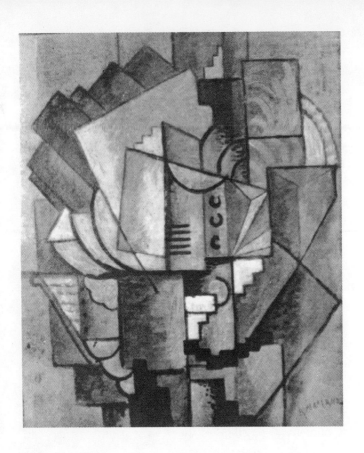

Malevich. Cubist still-life. 1913

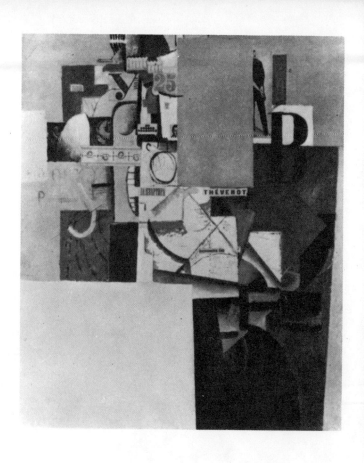

Malevich. *Woman beside Advertisement Pillar.* 1914

Malevich. *Suprematist Composition.* 1914

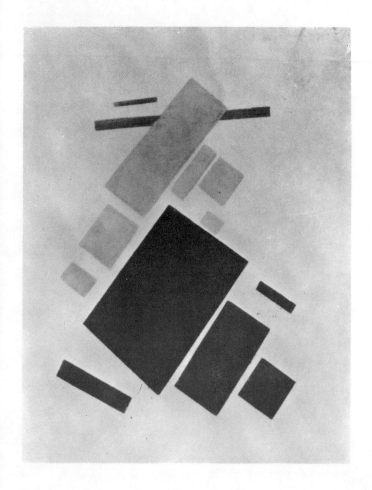

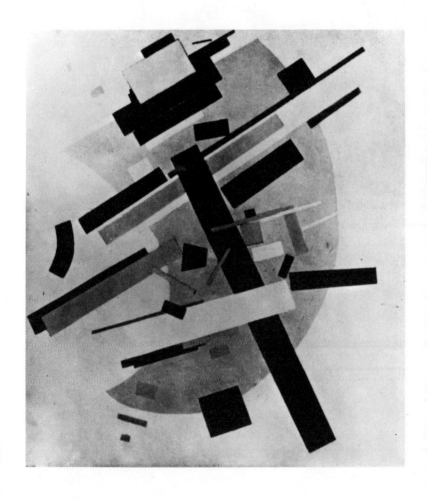

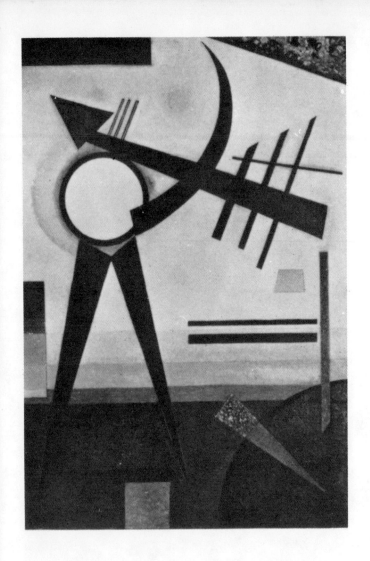

Kandinsky. *Green Wedge.* 1925

One might argue that it was remarkable but not unique. From about 1905 onwards a sense of radical change was beginning to inspire avant-garde artists in other countries: the Futurists in Italy; the De Stijl group in Holland; Der Blaue Reiter in Germany; the Vorticists in England. But there was a significant difference of emphasis, largely due to the fact that for the Russian artists their own bourgeoisie was relatively unimportant *as an obstacle*. Hence there was no need either to shock the bourgeois or to accept his categories. The Russians exhibited none of the destructive frenzy of the Italian Futurists. (So-called Russian 'Futurism' was informed by a quite different and far more rational and constructive spirit.) They seemed free from the tendency to moral absolutism which characterized the Dutch movement. And they were seldom introspective – in the same tortured sense as the Germans: there was no retreat inwards from the consequences of politics.

The works of Malevich, Lissitsky, Kandinsky, Tatlin, Pevsner, Rodchenko differ a great deal from one another in spirit. At one extreme Tatlin denied the difference between art and any other productive activity; at the opposite extreme Kandinsky believed that art was valid only if it followed a mysterious and idealistic 'inner necessity'. Yet despite their differences, all had one attitude in common – and it is this which, at that period, can be defined as specifically Russian. All believed in the profound influence that art could have on individual and social development: all believed in the social role of art. Yet their social consciousness was affirmative rather than critical. They saw themselves as already representing the liberated future. This liberation meant the breaking down of all divisions between classes, professions, disciplines and previous bureaucratic categories. Their works were like hinged doors, connecting

activity with activity. Art with engineering; music with painting; poetry with design; fine art with propaganda; photographs with typography; diagrams with action; the studio with the street, etc.

Kandinsky was ideologically the most aloof of these artists, but this is how he wrote about his feelings when he was working in Germany in 1910:

The corruptive separation of one art from another, and further-more of 'art' from folk art and children's art, from 'ethno-graphy', the firmly established walls between what I considered to be related or even identical manifestations, in a word, the synthetic relationships, gave me no peace. Today it may well appear strange that for a long time I could find no helpers, no means, simply not enough interest for this idea.*

A great deal of what was produced or planned around 1917 has been lost. Much of it was ephemeral.

Yet the paintings and constructions which did survive, the very notion of the artist–engineer, the polytechnic art training and research programmes worked out by Kandinsky (first for Moscow and later for the Bauhaus in Germany), the startlingly new typography and format of books and posters, the combined use of poetry and visual images, the example of ideograms like Lissitsky's *Beat the Whites with the Red Wedge*, drawings of monuments which were never put up because of lack of resources, stage designs for the Meyerhold Theatre, the accounts of agit-prop trains in which artists toured the country to explain graphically and verbally what was happening and what was necessary, entirely original experiments with exhibition techniques, the planning by artists of public celebrations such as the formalized re-enactment in October 1918 of the Revolution

* *Das Kunstblatt* XIV, 1930, p. 57.

in front of the Winter Palace, the extremism of artists like Tatlin who, faced with the country's basic problems of survival, abandoned art to apply his visual experience and intelligence to the designing of stoves (maximum heat with minimum fuel), the energy that couples and uncouples Mayakovsky's poetry:

> We will smash the old world
> wildly
> we will thunder
> a new myth over the world.
> We will trample the fence
> of time beneath our feet.
> We will make a musical scale
> of the rainbow.
>
> Roses and dreams
> Debased by poets
> will unfold
> in a new light
> for the delight of our eyes
> the eyes of big children.
> We will invent new roses
> roses of capitals with petals of squares.*

– all this, seen as a threat by some and a liberation by others, served notice to the rest of Europe that the role of the artist in the coming world would be very different.

* *The 150,000,000*, 1919–20. Translation by Anna Bostock.

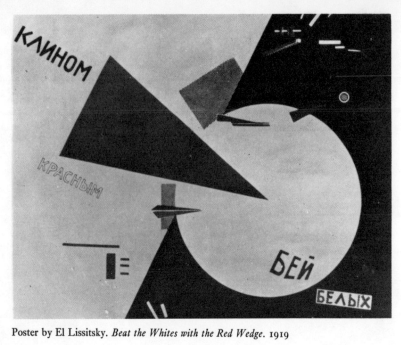

Poster by El Lissitsky. *Beat the Whites with the Red Wedge.* 1919

Design by El Lissitsky. People's Tribune. 1924

Stage set for Meyerhold Theatre by Varvara Stepanova. 1922

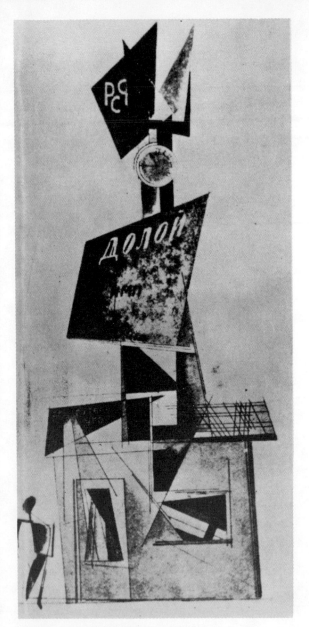

Kiosk project by Rodchenko. 1919

Some of the 'Leftists'' theories can easily be criticized for their over-simplification. The artist–engineer is only one kind of artist: there are also artist–philosophers. The work of art and the machine product are not precisely the

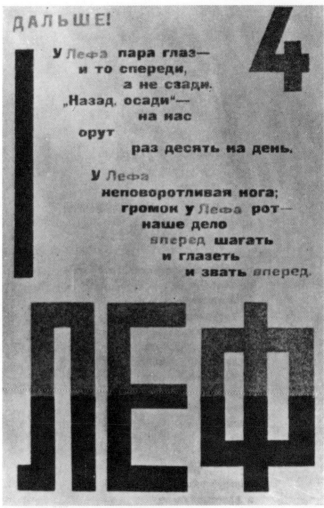

Page from magazine *Lef* designed by Rodchenko with poem by Mayakovsky. 1923

same. Yet their over-estimation of the machine is understandable enough in the context; the idea of industrialization had acquired a lyrical power, for it seemed to offer a way of avoiding, instead of suffering and enduring, a whole phase of history. The same lyricism is latent in Lenin's slogan that Communism is electrification plus the Soviets.

More important than the exaggeration of the Leftists was their prophetic vision. Cubism had destroyed the existing formal means in art: the categories within the canvas or sculpture. They proceeded to destroy the wider categories as between different media and as between the artist and the public for his art. No artists had ever lived and worked as they did. Their example rendered the Professional Painter and Sculptor (Professional in the sense of belonging to one of the middle-class Liberal Professions) as obsolete as the *fin-de-siècle* Bohemian or the *artiste maudit*.

> To work in a factory
> blacken your face with smoke
> then at leisure later
> to flap bleary eyelids at
> other men's luxuries –
> what is the good of that?
> Wipe the old out of our hearts!
> Enough of penny truths!
> The streets our brushes
> the squares our palettes.
> The thousand-paged book of time
> says nothing about the days of revolution.
> Futurists, dreamers, poets,
> come out into the street.*

* Vladimir Mayakovsky. *An Order to the Art Army*, December 1918. Translated by Anna Bostock.

44

Their vision has been criticized as being naïvely remote from the actual social reality.

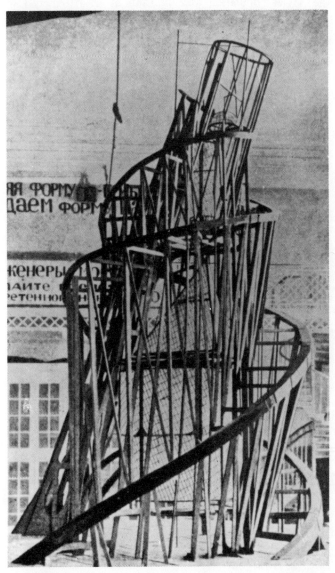

Tatlin. Monument to the Third International

What can Tatlin's Monument to the Third International mean to a peasant with a wooden plough? The majority of the Soviet population were peasants at an extremely low cultural level. Yet what does the existence of the Third International – quite regardless of any monument – mean to such a peasant? There is often a tendency to expect the artist to solve – as if by magic – problems whose solution depends upon there being more factories, schoolteachers, roadmakers, radio engineers, etc.

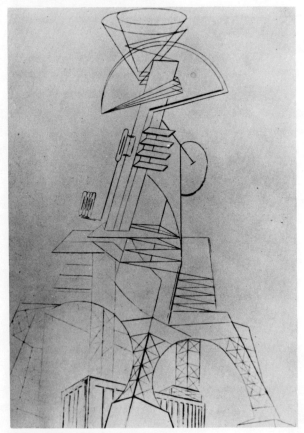

Naum Gabo. Project for a radio station. 1919–20

If Gabo's radio station had been built, Tatlin's monument would have made sense more quickly.

There is always a danger that the relative freedom of art can render it meaningless. Yet it is this same freedom which allows art, and art alone, to express and preserve the profoundest expectations of a period. It is part of the nature of man to expect more than he can immediately achieve. His expectations are never independent of necessity, but *the necessary should never be confused with the immediate.*

Art deals only with what is, and by intensity extracts therefrom for the shaping of what will be, which is the essence of what should be – given perfect extraction.*

Academicism has to be founded upon a hierarchy of established categories: it needs them for the application of its general and purely theoretical laws. It also needs them, administratively, for the working of its system of rewards and restraints.

For a few years after 1917 the condition of Russian art was the very antithesis of that which had preceded it for nearly two centuries. 'We have taken by storm the Bastille of the Academy,' claimed the students. For a few years artists served the State on their own initiative in a context of maximum freedom. Soon a very similar academicism was to be re-imposed.

In 1932 painting and sculpture in the Soviet Union were put under the centralized control of the Union of Artists. The Academy was re-established under the direction of Isaak Brodsky, who had been trained in the pre-revolutionary Academy and was known, even before the Revolution, for

* Philip O'Connor. *Journal.* To be published by Jonathan Cape.

the violence of his condemnation of all post-Impressionist painting. Yet it was not this suppression by statute which really put an end to Leftist art. Its spirit had been weakened by bad organization, personal quarrels, defections, but more fundamentally its spirit had been destroyed by other developments in the Soviet Union: by the denial of egalitarianism and the approved growth of privilege, by the unnecessary savagery with which the collectivization of the farms was being carried out, by some of the temporary but terrible consequences of the crash programme of industrialization. It was no longer possible for a few artists to believe that they represented the already liberated. They had to abandon their total prophetic claims and resign themselves to becoming good workers in a single productive sector. Tatlin concentrated on theatre design and ceramics, Lissitsky on exhibition layout, Rodchenko on typography and photo-montage; Malevich retired from public life altogether.

*

Guerassimov. *Stalin and Voroshilov at the Kremlin.* 1938

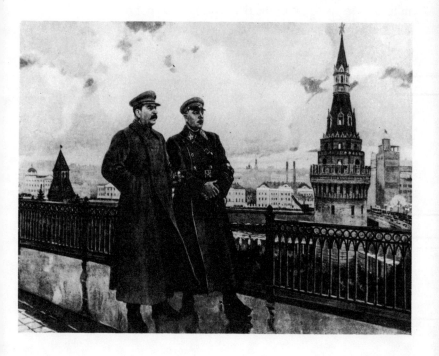

The newly imposed academicism – under the name of Socialist Realism – was officially justified on the grounds of being popular, and of meeting the demands of the vast new public who, in a socialist State, had a right to art. In fact it seems very unlikely that any of the paintings or sculptures produced from 1930 onwards ever achieved true popularity. Either their ideological optimism was too brutally contradicted by everyday experience, or if they were 'pure' landscapes they were compared unfavourably with their nineteenth-century prototypes. (A few paintings, such as Brodsky's portrait of Lenin at Smolny, probably did win a place in people's hearts as 'memorials'.) Yet although the works were not genuinely popular, the art policy of which they were part had a profound influence on the popular appreciation of art. Before we examine this influence, let us consider the theoretical claims put forward for this academic 'popular' art. They are claims that are still being made.

We must distinguish between naturalism and realism. Naturalism is unselective: or rather, is selective only in order to present with maximum credibility the immediate scene. It has no basis for selection outside the present; its ideal aim would be to produce a replica, thus preserving the present. Such a replica is impossible because art can only exist within the limitations of a medium. Consequently naturalism relies upon tricks of illusionism to distract attention away from the medium. (Vernacular, exact dialogue, facts that are unexpected in literature, illusionist effects of texture, highlights, etc.)

Realism is selective and strives towards the typical. Yet what is typical of a situation is only revealed by its development in relation to other developing situations.

Thus realism selects in order to construct a totality. In realist literature a man represents his whole life – though perhaps only a small part of it is described – and this life is seen or felt as part of the life of his class, society and universe. Far from disguising the limitations of his medium, the realist needs and uses them. Because the medium is limited, it can contain within its own terms and create a totality out of what in life presents itself as uncontained. The medium becomes the palpable model of the artist's ordering consciousness.

(The limitations of art relate to its content as death does to life. If, while fully conscious of death, we could concentrate our entire attention upon life, what we experienced would acquire the quality of a work of art.)

The distinction between naturalism and realism has been applied to literature, notably by Lukács, in a highly lluminating way. It is a distinction between two attitudes towards experience – formed, in the main, by the artist's imaginative and intellectual grasp of what is happening, that is to say what is changing, in his world: a distinction between a submissive worship of events just because they occur, and the confident inclusion of them within a personally constructed but objectively truthful world view. The distinction ought to apply also to the visual arts, but up to now nobody has applied it with sufficient insight.

We can, by analogy, recognize and talk of naturalism in the visual arts; but realism remains undefined. Not because it is a meaningless notion, but because up to now it has been treated as a stylistic category, descriptive of a certain kind of subject – vigorous and popular – and of a certain way of rendering the appearance of this subject as faithfully as possible without succumbing to the obvious detailed triviality of naturalism. In effect realism has been treated

by theoreticians, ministers of culture and planners as though it were what naturalism ought to achieve but doesn't. The reality to which realism has been assumed to refer has been no more than one aspect of a fragment. Realism has never been considered as a model for conveying the character of a totality. This is the reason for the relative failure of Marxist aesthetics in relation to the visual arts. (It may be that the so far unpublished writings of Max Raphael will shed light upon this problem.)

Realism must be distinguished not only from naturalism, but also from other attitudes and modes of expression which tend to isolate experience and render it static: symbolism, mannerism, subjectivism, didacticism. All these use art to simplify rather than contain experience. Yet clearly the distinction can only be made in a given historical context by reckoning the possible complexity of any imaginable totality at that moment. Realism is not a fixed measure but a variable and comparative achievement.

The most complex total reality which man could once imagine was God. Realism is the attempt to grasp that totality in terms of man: man with his 'stolen essence' – as Feuerbach defined God – restored to him.

Thus we can see the absurdity of measuring realism by the degree of approximation to a current convention of appearances: convention because what we mean by appearances is anyway only a fraction of what is seeable.

This, however, is exactly what the Soviet apologists for Socialist Realism have done. For them realism is naturalism which succeeds. And the secret of success lies, once again, in the choice of subject matter. It is true that they do refer to the *treatment* of the subject: but by this they mean the conscious ideological emphasis given to the subject. The treatment has been thought out, decided upon

and finished before the painting begins. It is a question of applying the right dogma to the subject. The act of painting consists of illustrating the 'treated' subject in the most transparent way possible. The medium and the function of its limitations are totally ignored. There is nothing dynamic for the medium to contain. Indeed the only hope of making the static illustration seem to live is to deny the limitations of the medium and to pretend that the medium is as infinite as life itself – hence the seeking after imitative effects. The formula, at its purest, is as follows: first create, according to the demands of purely theoretical dogma, an artificial or hypothetical event; then paint it with maximum naturalism, so that it appears to have been taken from life. Thus naturalism becomes a kind of alibi for the unnatural and the false.

The apologists for Socialist Naturalism – masquerading as Socialist Realism – tend to distract attention from the fundamental and very complex aesthetic problem of realism in the visual arts as I have outlined it above, by insisting upon two other claims.

It is claimed that the style of naturalism (called realism) is the most accessible to the masses because it is the nearest to natural appearances. This claim ignores most of what we now know about the process of perception, but even more obviously it is belied by child art, folk art and by the ease with which a mass adult urban population learns to read highly formalized cartoons, caricatures, posters, etc.

It is further claimed that the style, on account of its simplicity, lends itself to agitational propaganda: by such art the masses can be educated and made politically conscious. History contradicts this argument. There seems to be no significant difference between the Socialist Realist art of the 'thirties and of today. If its effect had been truly educative, one would expect a development in the art

corresponding to the development in the political conscious-
ness of the people which the art had helped to bring about.

More profoundly, the official apologists for Socialist
Realism have misunderstood the relationship between art
and propaganda.

It is true that all works of art exercise an ideological
influence – even works by artists who profess to have no
interest outside art. It is equally true that a revolutionary
government has need of every ideological weapon available.
But having said that, one must differentiate between works
which are intended to have an immediate and short-term
effect and are expendable, and works which are intended to
be more enduring. Such a distinction was deliberately ig-
nored by Stalin, who used Lenin's essay *Party Organization
and Party Literature* to justify his own policy of treating
all media and all means of expression in the same dogmatic
way. In 1960, however, an unknown letter of Krupskaya's
was published* in which she declared that Lenin had
not meant this essay to apply to literature as a fine art.
Thus it seems likely that Lenin made a similar distinction.
The point remains important for all future revolutionary
governments.

The short-term works, which can justifiably be subsumed
under propaganda, must reveal in their structure and form
their urgent but temporary function. They should be like
'orders of the day'. If they are not, much of their necessary
urgency is lost. Their purpose is to inspire for the immedi-
ate task or sacrifice; and the inspiration depends upon the
critical uniqueness of the moment. More than that, if

* *Druzhba Narodov*, 1960, no. 4. This letter is quoted by Ernst Fischer in
Art and Ideology (to be published by Allen Lane The Penguin Press and
George Braziller, New York), and Fischer discusses the questions raised by
it at greater length than I can do here.

orders of the day appear to be, and are accepted as, permanent orders, they become in time a barrier to further development. Injunctions which are suitable for a siege are of little use in an attack.

Works which are intended to have a long-term effect need to be far more complex and to embrace contradictions. It is the existence of these contradictions which may allow them to survive. They need to be concentrated, not upon the isolated exigencies of the moment, which can only be made total by social action submitting to and mastering them, but upon the new, now imaginable totality which reality represents. It is to the great advantage of the Russians that they think of art as prophetic. It is their tragedy that under the autocracy of Stalin, the belief in the prophetic quality of art was subtly but disastrously transformed into the belief that art was a means of definitively deciding the future now. The new totality which reality represents is by its nature ambiguous. These ambiguities must be allowed in long-term art. The purpose of such art is not to iron out the ambiguities, but to contain and define the totality in which they exist. In this way art becomes an aid to increasing self-consciousness instead of an immediate and limited guide to direct action.

Oil paintings, sculpture and, in most circumstances, mural painting do not, as media, lend themselves to propaganda. Their facture suggests too great a degree of permanence. Furthermore they are functionally inefficient media for propaganda purposes. A painting or a statue can only be in one place at one time, seen by a very limited number of people. The possible modern media for propaganda are the film, the ideogrammatic (not naturalistic) poster, the booklet, certain forms of theatre, the song, and declamatory poetry.

Nothing reveals more vividly the contradictory conservatism of so much Stalinist thinking than the condemnation of the Leftist activists who organized agit-prop trains with a true sense of the effective use of the media available, and their replacement by artists in smocks working in their studios on propaganda oil paintings which were put into gilt frames so as to be recognized as *objets d'art* and then dispatched to a semi-literate peasantry who were being enjoined, in all that concerned their own property, to give up the values and habits of centuries.

V. Yakovlev. *Gold Seekers Writing a Letter to the Creator of the Great Constitution*

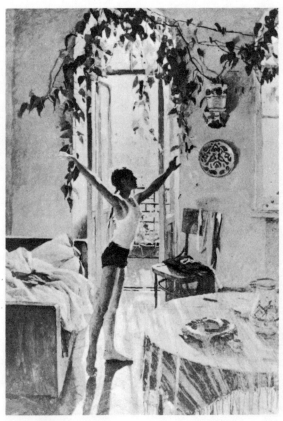

T. Yablonskaya. *Morning*

What was the result? The result is the Soviet public's present attitude towards the visual arts: an attitude which is shared by the vast majority, irrespective of occupation or position. Among the exceptions are some of the young who have matured during the last ten years, when there has been at least a hint of an alternative to the official art, and some of those who have been trained to analyse and question for themselves – mostly scientists.

By organizing exhibitions, by encouraging local Soviets and trade unions and the Komsomol to commission and buy works (but always via the central authority), by publishing books, by ensuring that there are references to works of art in the school syllabus, by maintaining museums and arranging visits, by the use of mural painting in public buildings, by the setting up of amateur painting groups in factories, by the programmes arranged in the palaces of culture, the official art programme, which began in the 'thirties, has made the entire Soviet people aware and proud of the fact that the visual arts can enter and play a part in their lives. The widespread public indifference to the fine

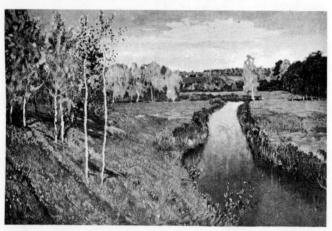

I. I. Levitan. *Autumn Morning.* 1895

arts as found in Britain, Germany or the United States would shock even the least privileged provincial in the Soviet Union.

The works which became popular were not, as I have said, the new Socialist Realist paintings but late nineteenth-century pictures, painted in the same style but with more skill and very much greater sincerity.

Typical of these are Levitan's *Autumn Morning* and Vasnetsov's *The Warriors*.

It is not difficult to see why such pictures became popular. They were – or anyway came to be thought of as – quintessentially Russian. Every member of the vast new public for art could feel that he himself had touched the equivalent of the kind of experience incorporated in these pictures.

The same Russian autumn, which is idealized in Levitan's painting, recurs many times in Turgenev.

And a clear, autumnal, slightly cold day with frost in the morning, when the birch, literally a tree out of a fairy-tale arrayed all in gold, stands out in beautiful outline against a pale-blue

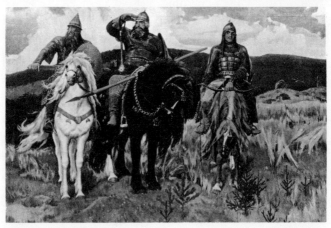

Vasnetsov. *The Warriors*

sky, when the sun, low on the horizon, has no more power to heat, but shines more brightly than the sun of summer, when the small aspen wood glows through and through as if it were delighted and happy to stand there naked, when the hoar-frost still whitens the floors of the valleys, but a fresh breeze ever so quietly rustles and drives before it the fallen twisted leaves, when blue waves race gaily along the river, making geese and ducks scattered on its surface bob evenly up and down; when in the distance a watermill, half hidden by willows, makes a clattering sound and, colourfully flickering in the bright air, pigeons circle swiftly above it . . .*

Vasnetsov's painting of the three legendary heroes, guardians of the Motherland, reminded the public of the invincibility of Russia when attacked: a truth last proved in 1919 and in a few years' time to be proved again at the cost of 20 million Russian lives.

The violence of modern Russian history, the scale of the country, the unevenness of historical development, the rate of transition, increased the popular attraction of an art in which an apparently unchanging Russian identity could be confirmed. At the same time such art ideologically served the conservative nationalism which necessarily accompanied the Stalinist policy of Socialism in One Country.

The official art hierarchy greatly exaggerated the effect of the ideological content of their new art, but otherwise they achieved what they set out to do:

1. To inculcate a sense of a national cultural tradition which the arts served. (The idea that, to some extent, the arts formed this tradition was discouraged; the arts were servants to whom was bequeathed, not, as with Louis XIV, a monarch's personal fame, but the State's honour.)

* *Sketches from a Hunter's Album.* Translated by Richard Freeborn. Penguin Books, 1967.

2. To make the masses proud and conscious of the privilege of art. Art was defined in the popular mind as a social privilege because it faithfully followed in form the art of the old ruling class. Oil paintings in gilt frames. Public buildings conceived as palaces. Ceilings with frescoed skies painted upon them. Public doorways with caryatids. Underground stations lit by imitation candelabra. The sense of privilege was intended to compensate for the many material sacrifices being demanded.

The Soviet public has been made aware of its right to art, but it is incapable of developing that right because it has no experience of its own art. When an art which corresponds more closely to its own time and its own historical role becomes available, its artistic self-consciousness will develop. But at first it will tend to resist this new art. We will understand why if we understand the subjective mechanism of its present appreciation of art.

A naturalist art whose style had no popular roots – it was the style of the nineteenth-century middle class in Western Europe – was disseminated to a vast, culturally backward public by a centralized government. (It is true that there were programmes for encouraging local national art and local national styles, but these were subsumed under The Encouragement of Folk Art and so were treated, according to the true academic tradition, as something quite separate from and inferior to Fine Art.) The art which was made available corresponded in form and style to the art of the old ruling class – only its subject matter was sometimes different. The most popular works – because they appealed to a sense of national tradition deriving from the past – were nineteenth-century ones.

It is scarcely surprising that the public came to think of the production of art, that is to say the *process of art*, as

mysterious, remote and beyond their interest. When a work of art finally reached them, it reached them as something already finished, as a *fait accompli*. (The parallel with the way in which major political decisions reached them is no accident.) And so they came to think of art, or rather of the value which art bestowed upon its subject, as historical and timeless, as something *given* instead of arrived at.

Painting and sculpture became for them a way of bestowing upon certain experiences a special, mysterious value, a kind of immortality.

When Russians talk about a visual work of art, they often speak with great feeling and sensitivity about the experience contained within it, the original experience of the subject, the experience which has been preserved by being painted. But when they talk about their experience of the work itself, about what the artist has done, they usually talk in banal clichés.

The attitude has something in common with the earlier religious one and may well have remained influenced by it. (An historically intermediate example is Tolstoy's treatment of the artist Mihailov in *Anna Karenina*.) The ikon makes the world as one sees it credible. The modern picture confirms the value of the spectator's already defined experience of the world by offering up that experience to the tradition of national culture, and thus making it sacred.

Hence the intense spiritual energy of Russian art appreciation, even when the works concerned are poor: a spiritual energy which is in marked contrast to the cynicism, hedonism and sensationalism of much art 'appreciation' in the West.

But hence also the impasse, the inability to develop. When the experience is 'offered up', it is not expected to be in any way transformed. Its apotheosis should be instant

and, as it were, invisible. The artistic process is taken for granted: it always remains *exterior* to the spectator's experience. It is no more than the supplied vehicle in which experience is placed so that it may arrive safely at a kind of cultural terminus. Just as academicism reduces the process of art to an *apparatus* for the artist, it reduces it to a *vehicle* for the spectator. There is absolutely no dialectic between experience and expression, between experience and its formulation. Yet the more developed and the more complex a culture, the more radically each individual experience has to undergo *continual* transformation in order to remain always comparable with and relative to other experiences.

Official Soviet policy after 1930 not only re-imposed a sterile academicism on the practice of art, it also blocked the development of the very public which it created for art. In both cases the consequences were retrogressive.

*

Today, in 1968, Neizvestny works in a disused shop in a back street near the centre of the city. The many studios in Moscow are reserved for official artists working mostly on official commissions.

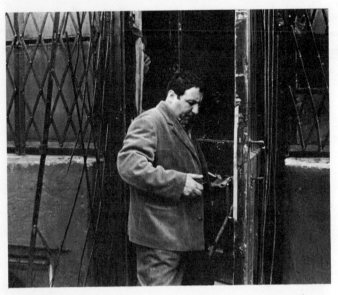

The shop is small – about 5 by 7 metres. At the back is a steep staircase like a ladder which leads to a tiny upper room, just large enough for a bed, a table and book-case without there being sufficient space to pass between them.

Downstairs in the shop is most of the sculpture he has made during the last ten years. In the upper room are many portfolios and parcels of drawings.

At first glance it seems that there is no space for him to continue working – except perhaps on the table upstairs. The shop is so crowded with carvings, plaster casts, bronzes and models in clay and plasticine that the simplest movement requires calculation. A careless gesture when talking can be disastrous.

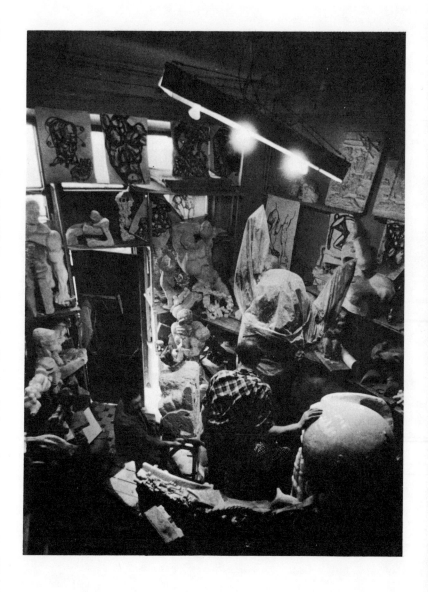

Neizvestny in his workshop. Photo: Mohr

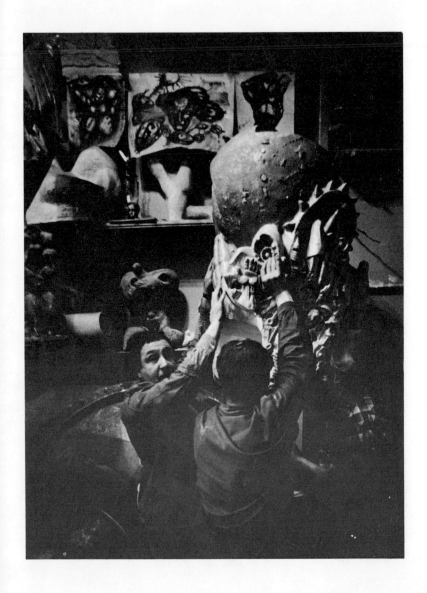

Among the works which fill this disused shop are maquettes for very large-scale public monuments, which have not been put up. Neizvestny thinks of sculpture as being essentially a public art. He would agree with what Lipchitz said thirty years ago:

For myself I believe that sculpture is essentially an art for crowds, and must be conceived and executed with this in mind. The great sculpture of all times has been an art in which everyone could find something of himself. But if the artist thinks of the people, they must think of the artist: great art is always the result of such reciprocal identification.*

In the shadow of one of these maquettes is his present working space. The space is badly lit. When working, he relies more on his fingertips than on his eyes.

If he needs to work on a large sculpture, he has to move or dismantle some of the larger bronze pieces, and for this he needs help. There are two men down the street who come to help him lift and carry. The people of the street are now used to his being there and to the strange contents of his shop which are so unlike any public art they have ever seen. They assume that these works are the result of a private passion, and the pursuit of a private passion surprises nobody in Russia. When the passion is over, the person concerned often tells his story, and its meaning is discussed. If it is a lifelong passion, the meaning is in the story itself.

*

* Jacques Lipchitz. *Cahiers d'Art*, 1935. Translation by author.

During the 1930s and 40s there were a number of artists who refused to accept the new academicism and who worked more or less independently: painters such as Falk or Tyschler or Konchalovsky.

A. Tyschler. *Woman and Aeroplane*

They were able to survive because they were discreet and because on occasions they were prepared to go some of the way towards meeting the official demands. This is not to suggest that they lacked either courage or integrity. Rather

it was the result of the nature of their opposition. They and their friends and students thought of themselves as 'liberals': opposed to the imposition of all rules and pro-grammes on art, which they consider to be, essentially, a matter for private choice. Thus their own opposition was not programmatic: it was a question of doing what, in a given set of circumstances, each individual conscience could allow.

Their art was oriented towards Paris and in their paint-ings one can sometimes see a similarity to Derain, Utrillo or certain of the milder Surrealists. They were consequently accused of 'cosmopolitanism', and although this is a meaningless charge, it is true that their approach had little to do with the rest of twentieth-century Russian art. They were as far removed from the Constructivists as they were from the Socialist Realists. They believed that the meaning of art was an aesthetic one, and that each individual had to find the meaning for himself. History was chaos and mis-fortune. Many of their attitudes were later to be displayed in a somewhat over-romantic light in the character of Doctor Zhivago.

They challenged the Academy, but their challenge was a quietist one of non-cooperation. Had it been more open, they would certainly have been destroyed.

Neizvestny today is not opposing 'private' art to public art. He is challenging official Soviet art by contesting its right to its own claims.

A more open challenge became possible after Stalin's death because monolithic orthodoxy no longer served the interest of any power group. Isaac Deutscher explains the logic of this new situation.

. . . Stalinism drove barbarism out of Russia by barbarous means. We should now add that it could not go on doing this

indefinitely. In Stalin's last years the progressive impact of his regime was increasingly nullified by the means he employed. In order to go on civilizing herself, Russia now had to drive out Stalinism. Nothing made this more urgent than the interference of Stalinist dogma with biology, chemistry, physics, linguistics, philosophy, economics, literature, and the arts – an interference reminiscent of the days when the Inquisition decided for the whole Christian world which were the right and the wrong ideas about God, the Universe, and Man. . . . Such intrusion of theological or bureaucratic dogma on the working of the scientific mind belongs essentially to a pre-industrial epoch. In mid-century Russia it amounted to a sabotage of science, technology, and national defence. Not even the narrowest sectional interest was served by that sabotage; and all educated people were eager to break it.*

Whether it was his political cast of mind which urged Neizvestny towards sculpture, or whether it was his pre-disposition towards sculpture which stimulated his political vision, it is impossible to say. But what is quite certain is that the two expressions of his character are reflected in the nature of sculpture itself. He could not have chosen another medium or art more likely to lead him, if he worked independently, into a direct confrontation with the bureaucratic and ideological machinery of the State academicism, which in its turn was a direct expression of a series of political assumptions.

'Sculpture is essentially an art for crowds.' Because we are surrounded by thousands of discredited public monuments – mostly hypocritical war memorials – and because the

* Isaac Deutscher. *Stalin.* Revised edition, Penguin Books, 1966, pp. 610–11.

whole bias of our culture is towards the fragmentary and private, we tend today to underestimate the civic, social nature of sculpture.

For centuries this was borne out by the special relationship which existed between architecture and sculpture. On an Indian temple or in a Gothic or Romanesque church, sculpture served as the imaginative particularization of the architecture: it is what rendered the general meaning of the building specific to each person. Painting was already different: it was one activity among others which took place within the building or on that site. Painting took advantage of the building being there. Sculpture was part of its being there. Such sculpture gathered, contained and dispensed the contributions of the particular which together constituted the general social act of building the building or of using it.

It is true that architecture, sculpture and societies have all changed profoundly since then. Yet, although they are no longer likely to be part of the same physical structure, there is still a special relationship between architecture and sculpture. Le Corbusier remarked that when you find the acoustic centre of a building or a piazza, the point at which all sounds within the given space can best be heard, you have also found the point at which a piece of sculpture should be placed. All architecture worthy of the name pleads to be *condensed* in this way. And it can only be condensed by another three-dimensional but this time nonfunctional and purely metaphorical structure – by sculpture.

The special civil and social nature of free-standing sculpture can, however, be deduced without any reference to architecture at all. Why are sculptures monuments? Why did the city of Rhodes commission its colossus?

Henry Moore. *Crowd Looking at a Tied-up Object.*
Chalk, pen, wash and watercolour. 1942

The obvious answer is that metal or stone – and to a lesser degree wood – have always been thought of as materials which endure. Yet the basic answer, I think, is less consequential than that and is implicit in one's first response on perceiving any piece of sculpture (except kinetic 'sculpture' which should logically be considered as a valid, indeed very promising, but totally different art-form).

A piece of sculpture is a static, three-dimensional structure filling or enclosing space. Yet its relation to space appears to be different from that of any other solid object. Compare a sculpture with a tree in winter. Because a tree grows, its forms are changeable and this is implicit in their shapes and configuration. As a result its relation to the surrounding space appears to be an adaptive one: there is a frontier, but it is not definitive or fixed.

Compare now a sculpture with a building or a bridge. Their relation to the space that surrounds them is different from that of the tree: their surfaces *are* fixed frontiers. But because they serve a practical purpose and must first meet the demands of their function, respecting within a safe and large margin all the relevant natural laws of force, they do not appear to be *primarily opposing* the surrounding space with which they have a fixed frontier: all their critical relations are ones of interdependence within their structure.

Compare, lastly, a sculpture with a machine which moves through space – an aeroplane or a crane. Because they move, the surrounding space appears relative to them: the aeroplane flies away and appears to take its space with it; the crane turns and claims the space in which it can operate, but between its claimed space and the rest of space, the frontier is invisible and unremarked. Only when a crane is still are we aware of its relation to the horizon or the depth of the sky.

A sculpture, however, appears to be totally opposed to the space that surrounds it. Its frontiers with that space are definitive. Its only function is to use space in such a way that it confers meaning upon it. It does not move or become relative. In every way possible it emphasizes its own finiteness. And by so doing it invokes the notion of infinity and challenges it.

We, perceiving this total opposition between the sculpture and the surrounding space, translate its promise into terms of time. It will stand against time as it stands against space. It is thus that a sculpture becomes a monument. We can, of course, refer to any work – a poem, an avenue, a hydro-electric plant – as a monument. But in no other case and in no other art is the monumental quality of the work so directly connected with our perception of it.

It may seem that this argument is too complex and sophisticated to apply to the age-old tradition of sculptural monuments. Were the citizens of Rhodes or the inhabitants of Easter Island aware, when they looked at a sculpture, of the notion of infinity?

They would not have formulated or analysed their feeling in the same way. But one can arrive at the same conclusion more simply. It is enough to make or look at a figure or head whose presence is constant. It is always there and, because it does not change, it appears to defy the passing of time and to promise continuity. One might argue that the same is true of a painting or any other man-made construction. The difference lies in the particularity and power of the presence and this can be apprehended and felt without analysing what actually creates the sense of presence – that is to say without analysing the relation between the figure and its surrounding space.

Yet what is the point of a sculpture appearing to defy

time and to promise continuity? A monument opposes to time the principle of duration. But the duration of what? Merely its own physical form and presence? We have only to ask the question to appreciate the importance of the social assumptions on which all monuments are founded.

A monument commemorates an event, a person, an idea, and it continues as a monument for as long as the public find the commemoration significant. It is from this that the Romantic image of the broken, forgotten monument derives.

> ... Two vast and trunkless legs of stone
> Stand in the desert ... Near them on the sand,
> Half sunk, a shattered visage lies ...
> Nothing beside remains. Round the decay
> Of that colossal wreck, boundless and bare
> The lone and level sands stretch far away.

Shelley intended the poem as a reminder that tyrannies pass. The rule of Ozymandias, King of Kings, is not only over: more important, it is forgotten. The fact that the statue is broken and abandoned is only incidentally the result of time: it is originally the result of social change.

We can now see why, in a society which considers and treats the arts as activities which can profoundly affect the ideological and political consciousness of the people, sculpture occupies a most controversial and central position. Nothing less is involved than the commemoration of the present values of that society addressed to its future: a commemoration which is not, as with the other arts, merely presumed but is intrinsic to the immediate impact – or lack of it – of the work as experienced today. A State can be judged by the future its sculpture sets out to promise it.

Neizvestny's struggle against the officially encouraged State art does not present itself in terms of the issues we have

been considering. Nevertheless it is these which give the struggle its philosophic content. And it is the content of his struggle which has made Neizvestny a legendary figure among many younger artists, poets, students.

A few years ago there was a competition for a Victory monument to be constructed near Moscow. Neizvestny submitted a plan and maquette. It consisted of a tunnel with figures representing the suffering of war on the dark inside walls. At the far end of the tunnel, in the light, there was a steel needle, the height of a tall building, and beside it an inverted pyramid standing on its apex. On the overhanging sides of this pyramid the names of war heroes were engraved. And on the flat top of the pyramid there was a lake: a sea of tears. The jury for the competition, which included a number of Red Army generals, voted his project the winner. The Academy intervened and eventually forced the plan to be dropped. The monument was never built.

This was a somewhat exceptional case, but it demonstrates a tendency. The struggle in the U.S.S.R. for the emancipation of the visual arts from Stalinist orthodoxy is by no means a simple struggle between imaginative artists on the one hand and philistine political leaders on the other. There are political leaders and pressure groups outside the field of art who would welcome, or who could be persuaded to welcome, a less conservative art policy. Yet this cannot be brought about without destroying or profoundly changing the organizational structure of the arts.

The visual arts have remained under the centralized control of the Academy of Fine Arts and the Union of Artists. Within these bodies there has been no real change of policy since Stalin's death. Due to a restriction of the power of the secret police and a more tolerant definition of

what constitutes a threat to the State, it has become politi-
cally less dangerous to oppose the official art policy. But
the aesthetic of Socialist Realism, despite references to 'the
cult of personality' and to the error of demanding purely
optimistic art, has remained the same as it was before.

The Academy with only thirty places represents the elite.
The Union includes all those who practise professionally.
Even some of the unofficial artists are nominal members. The
Moscow branch of the Union has 6,000 members. Between
the Union and the Academy there is a certain antagonism.
Members of the former believe that the Academicians have
been ill-chosen. The disagreement is expressed as one be-
tween the 'conservative' Academy and the 'liberal' Union.
But only a slight difference of emphasis is involved. The
real disagreement is about personalities and the distribution
of honours.

Artists as a whole are excessively privileged in the Soviet
Union. The elite live on an extremely lavish scale, far above
that of certain government ministers. Even the averagely
successful live far better than, say, the average engineer or
university teacher.

Among the most successful some of the older generation
are demoralized and cynical. They are consciously engaged
in defending their own personal privileges and they have
long since ceased to think of the successful practice of art
as anything but the shrewd handling of political bosses.

The majority are probably sincere. They believe in the
usefulness of what they are doing and the vast State pro-
gramme for the arts. (Approximately 50 million roubles a
year are spent on sculptural monuments alone.) These
artists have become institutionalized: they are the managers
of their own art-producing apparatuses. Like civil servants,
they are open to detailed and limited criticism of work

done. But any general attack against the system seems to them to be personally unjust and socially irresponsible.

There are those who are aware that the visual arts have failed to keep pace with the changes which have occurred – some of them fundamental as regards theory – in other fields: economics, physics, agronomy, literature. They would welcome reforms. But the reforms must not question the principles of the State art policy, or undermine the confidence of the public in the art which has already been produced. (We have seen how this confidence is actually no more than a public adaptation to what has been imposed.)

The Academy and the Union are both opposed to Neizvestny because they see his work as a threat. There are other non-conformist artists whose work is stylistically more extreme than his, yet of whom they are more tolerant. He is a threat because while he is working privately and in a spirit which is entirely uninstitutionalized, the import and intention of his work is public. It suggests an alternative not so much to the way that an individual artist may wish to develop, but to the official conception of the nature of public art. The charge against him is one of individualism, not because his work is idiosyncratic, but because *by himself* he challenges the State art policy. And this challenge, judged from the point of view of the administration, *is* irresponsible. A State policy for the visual arts cannot be changed overnight, as the example of one man might seem to suggest. But the conflict is not of Neizvestny's making. It is part of his inheritance.

During the last ten years Neizvestny has received one official commission – a large sculptural ensemble for the Artek Pioneers' camp in the Crimea. Its story is a story of intrigues, checks, bluffs, adaptations and threats. In 1967 it was finally accepted. Probably the work itself (I have not

seen it *in situ*) bears the marks of the struggle and the compromises. Neizvestny is not a purist: he is sometimes prepared to go half-way to meet official demands. This may offend those in the West who have a romantic notion of the rebel artist. But essentially Neizvestny is not a rebel. And that is why he is such a threat and his example so original.

Apart from this single commission, Neizvestny has worked on his own. He has earned a precarious living by selling small sculptures and drawings to private individuals, mostly scientists of one kind or another. All applications from abroad to buy his work are turned down by the 'Salon for the Sale of Art Objects'.

Yet it is virtually impossible for a Soviet sculptor to work independently and to remain within the law. A painter can buy his materials in a shop. A writer needs no materials. But how is a sculptor to acquire large blocks of wood or stone and the tackle for handling them? The Academy and the Union have the monopoly of all supplies. The only alternative is to buy them 'privately', which in effect means on the black market.

Even more critical for a sculptor who is primarily a modeller rather than a carver: how is he to have his works cast in metal? The State foundries only accept works for casting via the official art bodies. Neizvestny has installed a small furnace of his own at the back of his disused shop. The casts he can make from it are very small. A large figure has to be cast in many parts. The quality of the casts is coarse and rough. And again the metal in which they are cast has to be bought on the black market.

Thus the academic system has forced Neizvestny to become a petty criminal. The tragi-comedy of this situation was revealed by his famous confrontation with Khrushchev in November 1962. Yet any proper understanding of this

encounter and of the forces that drove the protagonists on must take into account the history of Russian art from Peter the Great onwards. The scene could not have been enacted in any other country. It may one day be seen to have marked the beginning of the end of the second period of academicism. It is still too soon to say.

Ullo Sooster. Drawing. Moscow, 1960

It happened like this. The Moscow Union of Artists planned to organize an exhibition of work done by members during the previous thirty years. The exhibition was to be 'liberal' in emphasis and was intended to draw attention to the narrowness of the Academy. Neizvestny was invited to participate because on this occasion his own record against the Academy might add weight to the Union's argument.

Neizvestny refused to participate unless some other experimental young artists were also invited. The Union refused. But the idea of having an exhibition of experimental, unofficial art was then taken up by a man called Bilyutin who was at that time running a teaching studio. Somehow he managed to arrange the exhibition under the auspices of the Moscow City Council. The exhibition was to include the work of Bilyutin's students, Neizvestny, and some other younger artists whom Neizvestny suggested. It is difficult to discover exactly why and how the exhibition was ever allowed to take place. It is possible that the Academy wanted a provocation in order to persuade the government that it must act to prevent the further spread of 'nihilism' – the revived label now attached to the non-conformists. It is equally possible that owing to bureaucratic inefficiencies and lack of liaison between departments, nobody realized what the exhibition meant until it was too late.

The exhibition opened and caused a sensation. Partly as a result of the works exhibited, which were unlike any works seen in public for at least twenty years: even more as a result of the enthusiasm with which the younger generation greeted them. The crowds and queues were beyond anybody's expectations. After a few days the exhibition was officially closed down and the artists were told that they

must bring their works to the Manège building, by the side of the Kremlin, so that all the problems raised by their work should be considered by the government and the Central Committee.

This official reaction, with its half-promise of a discussion and conclusions not already prejudged, represented a considerable advance from the days of absolute Stalinist orthodoxy. But at the same time there had been no declared change of policy. No one knew how far the apparent new tolerance would extend. None of the artists knew how gravely they might be condemned. Both the risks and the opportunities remained unknown. Everything depended on how Khrushchev might be personally persuaded. The enigma of personality was still the crucial factor.

Bilyutin suggested to the artists that they should leave their more extreme works behind and only take the more conventional ones. Neizvestny opposed this on the grounds that it would deceive nobody; also because here was an opportunity for having at least the existence of their work officially recognized.

The artists hung their own works in the Manège building. Several of them worked throughout the night. Then they waited. The building was cordoned off by security men. The gallery was searched. Windows and curtains were checked.

The entourage of about seventy men entered the building. Khrushchev had no sooner reached the top of the stairs than he began to shout: 'Dog shit! Filth! Disgrace! Who is responsible for this? Who is the leader?'

A man stepped forward.

'Who are you?'

The voice of the man was scarcely audible. 'Bilyutin,' he said.

'Who?' shouted Khrushchev.

Somebody in the government ranks said: 'He's not the real leader. We don't want him. That's the real leader!' and pointed at Neizvestny.

Khrushchev began to shout again. But this time Neizvestny shouted back: 'You may be Premier and Chairman but not here in front of my works. Here I am Premier and we shall discuss as equals.'

To many of his friends this reply of Neizvestny's seemed more dangerous than Khrushchev's anger.

A minister by the side of Khrushchev: 'Who are you talking to? This is the Prime Minister. As for you, we are going to have you sent to the uranium mines.'

Two security men seized Neizvestny's arms. He ignored the minister and spoke straight to Khrushchev. They are both short men of about equal height.

'You are talking to a man who is perfectly capable of killing himself at any moment. Your threats mean nothing to me.'

The formality of the statement made it entirely convincing.

At a sign from the same person in the entourage who had instructed the security men to seize Neizvestny's arms, they now released them.

Feeling his arms freed, Neizvestny slowly turned his back and began to walk towards his works. For a moment nobody moved. He knew that for the second time in his life he was very near to being lost. What happened next would be decisive. He continued walking, straining his ears. The artists and onlookers were absolutely silent. At least he heard heavy, slow breathing behind him. Khrushchev was following.

The two men began to argue about the works on view,

often raising their voices. Neizvestny was frequently inter-
rupted by those who had by now reassembled around the
Prime Minister.

The head of the Security Police: 'Look at the coat
you're wearing – it's a beatnik coat.'

Neizvestny: 'I have been working all night preparing
this exhibition. Your men wouldn't allow my wife in this
morning to bring me a clean shirt. You should be ashamed
of yourself, in a society which honours labour, to make such
a remark.'

When Neizvestny referred to the work of his artist
friends, he was accused of being a homosexual. He replied
by again speaking directly to Khrushchev.

'In such matters, Nikita Sergeyevich, it is awkward to
bear testimony on one's own behalf. But if you could find a
girl here and now – I think I should be able to show you.'

Khrushchev laughed. Then, on the next occasion when
Neizvestny contradicted him, he suddenly demanded:
'Where do you get your bronze from?'

Neizvestny: 'I steal it.'

A minister: 'He's mixed up in the black market and other
rackets too.'

Neizvestny: 'Those are very grave charges made by a
government head and I demand the fullest possible investi-
gation. Pending the results of this investigation I should
like to say that I do not steal in the way that has been im-
plied. The material I use is scrap. But, in order to go on
working at all, I have to come by it illegally.'

Gradually the talk between the two men became less
tense. And the subject was no longer exclusively the work
on view.

Khrushchev: 'What do you think of the art produced
under Stalin?'

Neizvestny: 'I think it was rotten and the same kind of artists are still deceiving you.'

Khrushchev: 'The methods Stalin used were wrong, but the art itself was not.'

Neizvestny: 'I do not know how, as Marxists, we can think like that. The methods Stalin used served the cult of personality and this became the content of the art he allowed. Therefore the art was rotten too.'

So it went on for about an hour. The room was very hot. Everyone had to remain standing. The tension was high. One or two people had fainted. Yet nobody dared to interrupt Khrushchev. The dialogue could only be brought to a close via Neizvestny. 'Better wind it up now,' he heard somebody in the government ranks say from behind his ear. Obediently he held out his hand to Khrushchev and said he thought that perhaps they should stop now.

The entourage moved across to the doorway on to the staircase. Khrushchev turned round: 'You are the kind of man I like. But there's an angel and a devil in you,' he said. 'If the angel wins, we can get along together. If it's the devil who wins, we shall destroy you.'

Neizvestny left the building expecting to be arrested before he reached the corner of Gorky Street. He was not arrested.

Later the investigation took place which Neizvestny had demanded. The minister withdrew his charges and declared that there was no serious evidence that Neizvestny was not an honourable man. The investigation included Neizvestny's being examined to see whether he was mad.

Before this examination but after the encounter in the Manège, Khrushchev, who had several long conversations with Neizvestny, asked him how it was that he could withstand for so long the pressure of the State.

Neizvestny: 'There are certain bacteria – very small, soft ones – which can live in a super-saline solution that could dissolve the hoof of a rhinoceros.'

The doctors reported to Khrushchev that they found Neizvestny sane.

Neizvestny. Studies of Dante's *Inferno*. 1965–7

Whirlwind

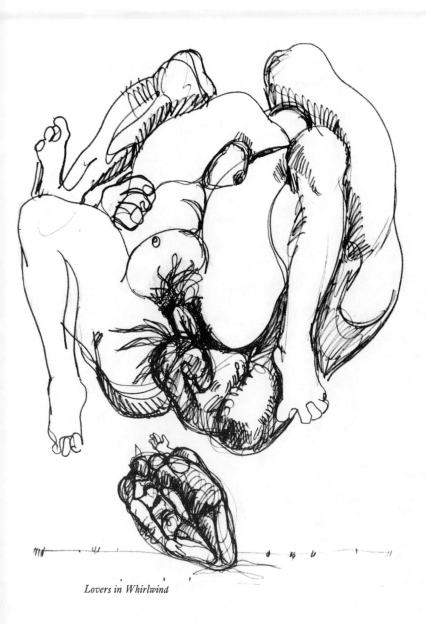

Lovers in Whirlwind

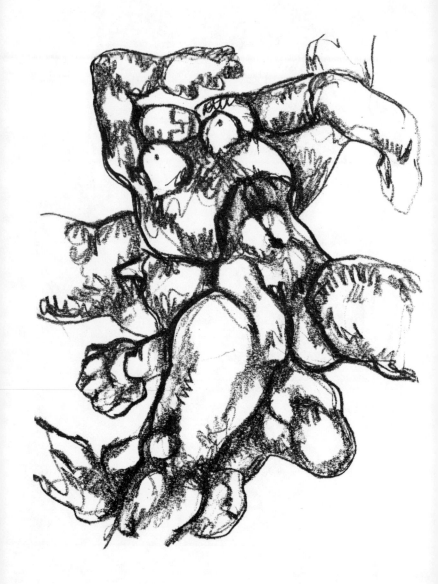

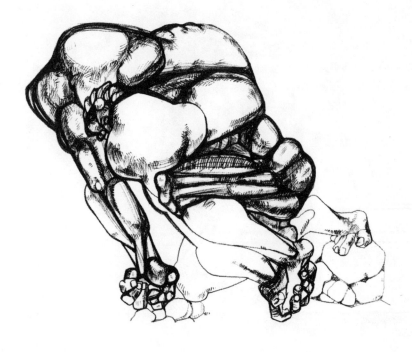

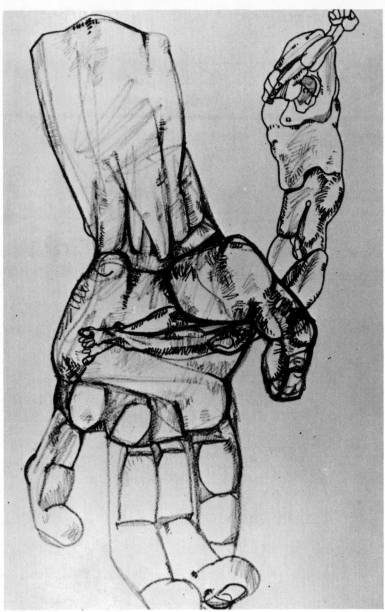

Hand of Hell

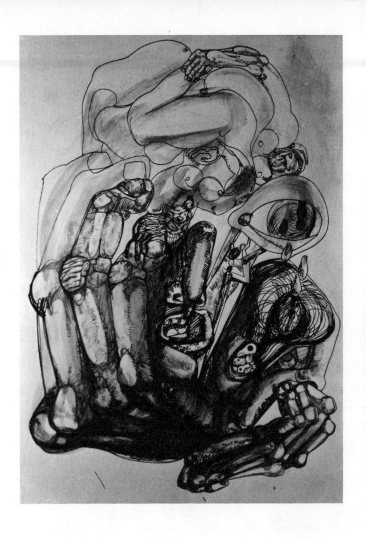

Strange Birth

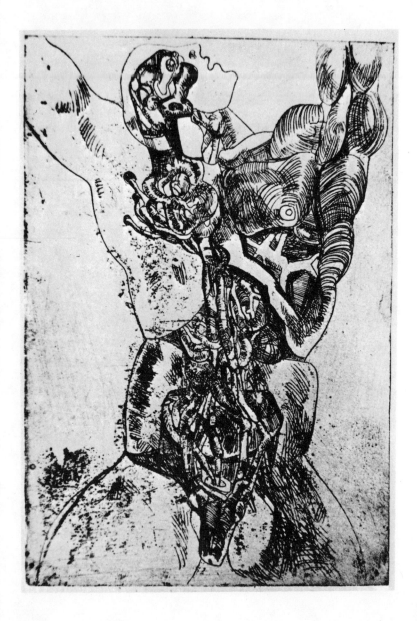

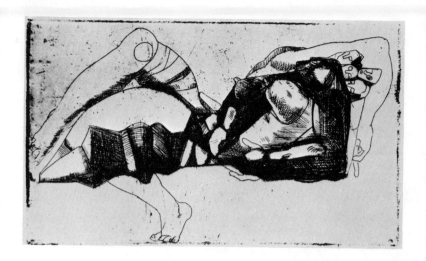

2.

To examine the spirit and the theme of Neizvestny's work. To try to delimit the world of his imagination.

I ask myself whether it is too soon to do this. As an independent artist Neizvestny has been working for just over ten years. It is not long. Yet since 1956 his development has been logical and unbroken. This is perhaps because he was already formed and mature as a personality (aged about thirty) when he was first able to work by himself; perhaps also because his mind is a naturally philosophic one. As an artist he needs to know where he is going. And so it seems to me that we can nevertheless trace the formation of the essential Neizvestny in such a way that no future development is likely to contradict it.

Some months ago, when I was beginning this essay, I went to Paris to revisit the Rodin museum. I thought that a comparison between Rodin and Neizvestny might be revealing. I could see obvious similarities of temperament: the same desire to produce an epic art; the same very evident sexual energy; a similar preoccupation with time passing. I wanted to discover the differences between them – not the difference in achievement, but in approach.

We arrived at the Gare de Lyon and before crossing the city to go to the museum we decided to have some coffee. It was one of those bright winter days in Paris: cold but with the sky a pale ceramic blue, as though the colour were compounded of the stone dust of the white and grey buildings beneath it. (There are a few paintings by Nicolas de Staël which are about this effect of light in Paris.)

We sat by the café window to look out on to the street. It was a fair-sized, busy street with quite a lot of traffic. Women were choosing vegetables at the *primeur* opposite – artichokes, leeks, endives, celery. Several wore boots and looked cold round their legs. Eight blind men with white

sticks assembled outside the café door. Each held on to another's coat and they were led by a man who wore glasses but was not blind. He led them into the café and after they had felt their way into the chairs round two tables, they began to rub the cold out of their hands. Then I saw the man on wheels.

He was lying on his back on a long flat piece of wood, like a table-top. He had blankets over his body and they were tucked in around his feet. His head rested on a bundle of clothes. He was able to raise his head sufficiently to just glimpse the end of the table by his feet. When he rested his head, he saw the sky and the top of the buildings on either side of the street. Except for this slight movement of the head it seemed that he was incapable of moving the trunk of his body at all. He had both arms free. With his left arm he propelled himself forward – for the wooden table was mounted on four bicycle wheels. Clamped to the edge of the table, like a coffee grinder, was a handle which turned a toothed wheel with a chain round it. Through a system of gears the turning of this handle turned the bicycle wheels. But extremely slowly. He was turning the handle quite fast, as though grinding coffee, and the whole vehicle was moving forward at about a quarter of a normal walking pace. At perhaps one mile per hour. With his right hand he controlled a steering mechanism which was on the far side of the table and which I could not see properly.

It took him several minutes to pass the length of the street visible from the café window. His progress relative to the doorways of the shops, the lamp-posts, the women buying their vegetables was as slow as the articulation of his body was restricted. Yet he was moving. He would reach his destination and return.

I imagined other streets and boulevards seen through his eyes, looking up at the continuous corridor of pale blue sky between the roof-tops.

And it was this vision, not what I later saw at the Rodin museum, which proved central to understanding Neizvestny's imaginative preoccupations.

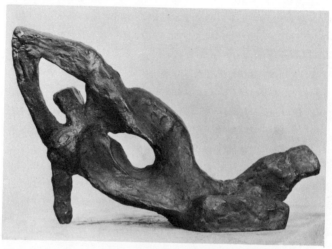

Neizvestny. *Wounded Man.* Bronze. Late 1950s

The poles of Neizvestny's imagination are life and death: a polarity so fundamental and general that it can seem banal. Yet for him it is particular and unique. It was first established by his own near-death when he lay for an immeasurable period of time on the ground where the small battle had been fought behind the German lines. It was there that he came close enough to death to acquire a fine eye for measuring our distance from it. (A distance about which most of us are vague or about which our judgement fluctuates absurdly.)

It would be wrong to conclude that Neizvestny is obsessed by death. I spoke of a *polarity*. Death for him is a starting point rather than an end. It is *from* death that he measures, instead of towards it. 'You are talking to a man who is perfectly capable of killing himself at any moment.' Consequently he is highly conscious of the energy of life even when it is least obvious. Those who measure towards death become very aware of the precariousness of life; Neizvestny, by contrast, is aware of the extraordinary adaptability and obstinacy of life.

This is why the man lying on his table-top by the Gare de Lyon is fundamental to his art.

One of Neizvestny's first independent sculptures, dating from 1955, is a small bronze of a soldier wounded by a bayonet (see p. 18). The man is about to collapse, as though all his joints were broken – and to become, perhaps, the Dead Soldier of two years later.

Neizvestny. *Dead Soldier*. Bronze. 1957. Photo: Mohr

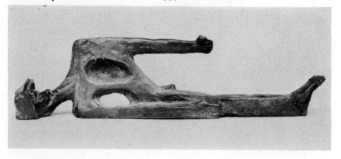

This is how Neizvestny sees death: rigid and still. I know of no other figure by him like this: so rectangular, so uniformly parallel.

In the same year he made another figure of a man with an artificial limb. The man is legless, but on the ground in

front of him is an 'artificial' leg which he is looking at and handling.

Neizvestny. *Man with Artificial Limb*. Bronze. 1957. Photo: Mohr

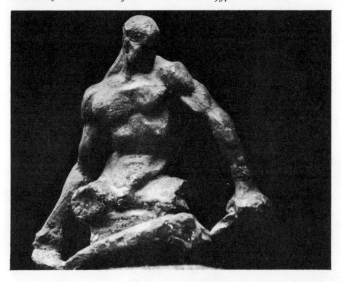

It is not, in my opinion, a successful work. But it illustrates Neizvestny's thinking. The fact that the man has lost his legs is fully admitted; indeed it is the explanation of the action of the figure and of its title. Nevertheless the emphasis of the work is on the fact that he has *not* lost his life. By comparing this figure with the *Dead Soldier* one can see all that Neizvestny means to imply: this mutilated man is a Prometheus because he is alive; his mutilation adds to his Promethean character by allowing him to show the extent of human adaptability, and the strength of the will to survive.

Such an attitude may seem callous. And indeed it would be if it were Neizvestny's only reaction to the actual case of a mutilated man. But the sculpture refers to an idea rather

than an actual case, and the materialization of this idea owes more to sculptural convention – the broken classical torso, the study of the isolated arm or leg – than to the reality of a man with both legs amputated.

In another work of the same year, which depicts a soldier pulling off his gas mask as the All Clear sounds, there is a far greater – indeed an intense – degree of identification with the actual subject.

Neizvestny. *All Clear*. Bronze. 1957. Photo: Mohr

But the idea behind the work is the same. The man pulls off the mask as though it were a shroud that has been covering his face, and the single eye which he thus reveals, bright, searching, wary, is testimony to the life that has survived, that has scrambled out of the valley of the shadow of death.

It is a commonplace to say that death is the contradiction necessary to life; and true none the less. But what is the manner of the contradiction? It is that, unlike life, death is without contradiction. Death is singular. No death includes another death. It contains nothing but itself, which is nothing. Because it is singular it is also only partial: no whole that we can imagine is ever singular.

The salvation of reality is its obstinate, irreducible, matter-of-fact entities, which are limited to be no other than themselves. Neither science, nor art, nor creative action can tear itself away from obstinate, irreducible, limited facts. The endurance of things has its significance in the self-retention of that which imposes itself as a definite attainment for its own sake. That which endures is limited, obstructive, intolerant, infecting its environment with its own aspects. But it is not self-sufficient. The aspects of all things enter into its very nature. It is only itself as drawing together into its own limitation the larger whole in which it finds itself. Conversely it is only itself by lending its aspects to this same environment in which it finds itself.*

Life can include death but not vice versa.

Neizvestny's early sculptures belong to the early stages of his progress from death as a starting point. They concern those who have passed or pass very near to death in the most obvious and direct way: the war survivors, the wounded, the maimed, the suicides.

* A. N. Whitehead. *Science and the Modern World*, 1936. Mentor Books edition, 1948, p. 89.

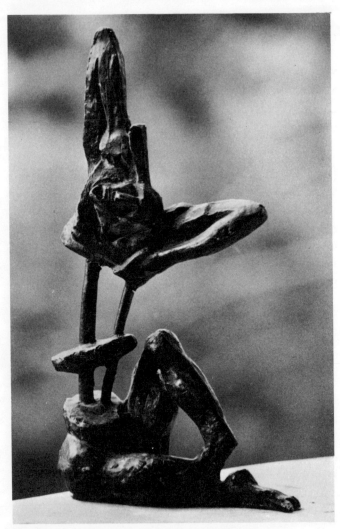

Neizvestny. *The Suicide*. Bronze. 1958. Photo: Mohr

Gradually his subject matter changed. There is no longer any direct evidence of death. But the sense of the energy of life is so extreme that it suggests the same starting point. This is how life must appear in the light of its negation.

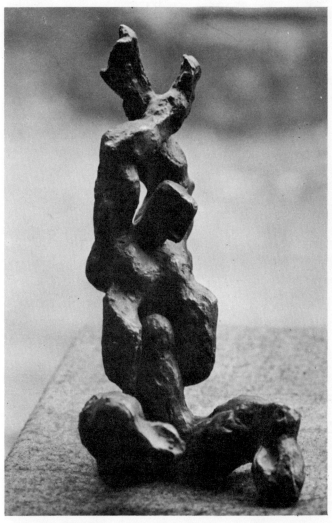

Neizvestny. *Adam*. Bronze. 1962–3. Photo: Mohr

Its contradictions are triumphant. Invisible forms, now made visible, are continually breaking open in growth and deliverance – like a magnolia tree on the day it bursts its buds.

As a result of recognizing contradiction, one discovers unexpected correspondences between apparent opposites. As a novelist, Dostoevsky was a master of the psychological insights afforded by this discovery. As a sculptor, Neizvestny is fascinated by experiences which correspond despite the apparent bodies in which they are experienced. The essential quality of the legless man is that he is alive, not that he is legless. On the level of Neizvestny's concern there is a correspondence, for example, between the experience of the man on the table-top by the Gare de Lyon and that of his apparent antithesis – the long-distance runner.

After running for a certain while, you get used to the quick breathing and the faster beating of your heart. And if then you throw your head back and continue to run, looking at the sky, you experience a curious sensation – the appetite for which grows, so that finally you may go running just in order to experience it. Your head feels fully supported by the back of your neck: it is as though it is resting on a cushion tied to your shoulder-blades. If you lower your eyes without moving your head, you can glimpse the path: it is slightly out of focus, blurred; but you can see enough to avoid obstacles. The hedges and trees and fields on either side are bars of colour, either horizontal or vertical, which differentiate the element through which you are running. If, however, you concentrate your attention on the sky you lose the sense of running. The engine of your body becomes something quite separate. You become its passenger. It is the depth of the sky that now engages you. The engine may run faster without your becoming aware of any increase of

either effort or speed. You are isolated from it by a kind of psychological mechanism of gearing. The distance you are covering becomes irrelevant compared to the extraordinary depth of that sky, a depth like that of sleep.

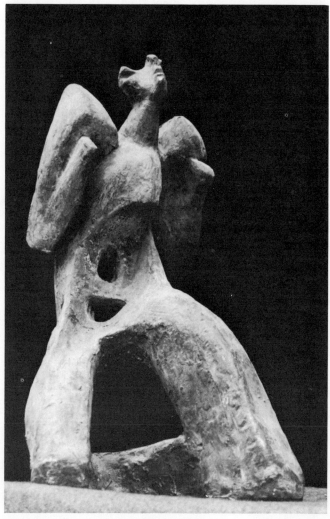

Neizvestny. *Effort*. Bronze. 1962. Photo: Mohr

*

We must now be more precise about Neizvestny's images, for we shall then gain a more concrete understanding of his imagination.

For Neizvestny the human body is the field of all possible metaphors. All that he has to say can be said in terms of the human body. It represents the quintessence of all that is not death.

Until the advent of abstract art the human body was the subject of all monumental sculpture. As a result it became charged with symbolism and underwent many different forms of idealization. Today it is no longer the inevitable subject. Therefore it is possible for an artist to choose the human body because of its intrinsic interest for him. This, I believe, is the case with Neizvestny.

In a different period he might have become an anatomist. Today, if he were practising medicine, he would probably be a neurologist. This is not to suggest that his interest is scientific, but rather that it begins at the same point as a certain kind of scientific interest in medicine: it begins with an insatiable curiosity about the body. He is not concerned with its beauty but with its workings, its power, its resistance, its limits and its mysteries.

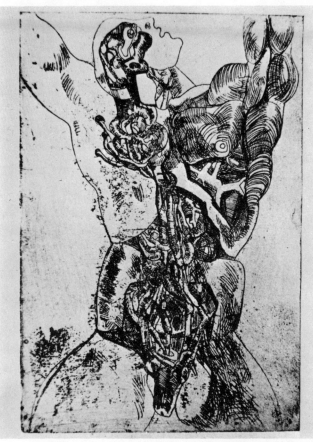

Neizvestny. *Human Anatomy*. Etching. 1966. Photo: Mohr

'The sculpture of antiquity,' said Rodin, 'sought the logic of the human body. I seek its psychology.' By psychology Rodin meant emotional drama. He thought of the body as an expression of what the mind or heart was feeling. One sees in the *Burghers of Calais* how each is contemplating in his own way the death to which he is walking. And one sees this as one might if one were watching a very great theatrical performance.

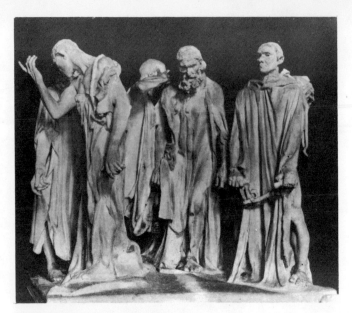

Rodin. *Burghers of Calais.* 1884–6

Neizvestny's interest is equally far removed from the sculpture of antiquity; but at the same time it is very different from Rodin's. (Although stylistically he sometimes indulges in a debased rhetoric which originated with the imitators of Rodin.) Neizvestny is not concerned with expression (outward manifestations) but with interior events within the body.

None of his figures can really be called a nude. Nudity with its thrill for puritans and its superficial promise for hedonists is still far too exterior for him. It is a half-measure. The two great sensuous and imaginative distinctions – between life and death and between male and female – are neither nude nor enjoyed at skin level. It is necessary to go further into the interior of the being until, ideally, we touch not the body but the experience of the body.

Even in the case of the simplest and most exterior of forms – the sphere – Neizvestny makes a distinction between inner and outer truth.

Two sculptors are carving a sphere out of stone. One of them wants to achieve the most perfect form of a sphere and sees the meaning of his work in turning a mass of stone into a perfect sphere. The other is also carving a sphere, but only in order to convey the inner tension expressed in the form of a sphere filled to bursting point. The first sphere will be the work of a craftsman; the second, that of an artist.*

The difficulty of definition arises when we ask what this interiority of Neizvestny's work means. To try to answer the question we must first digress.

'A broken heart', 'a wave of tenderness', 'a splitting pain', 'a man of iron nerve', a person 'eaten up with jealousy', 'the mind's eye', 'to know in one's bones' – all such turns of phrase, and there are many more in all languages, modify the substance or workings of the human body in order to describe the spirit of a quality or experience. They are the original metaphor. In the practice of magic the metaphor was treated as fact.

The human body, viewed singly and objectively, is inadequate to explain or express what we can feel within it. This truth cannot simply be dismissed as subjective, with the implication that it is not therefore essential. It is part of the nature of our self-consciousness. Self-consciousness is, by definition, a consciousness of ourselves in relation to what is not ourselves: thus the reflections of these relations become part of us and are internalized.

In classical mythology, there is a two-way traffic between the human body and exterior nature. Metamorphosis can

* Interview given by Neizvestny to *Soviet Life*. Date unknown.

work both ways. A man can change into a tree. The spirit of
a river can acquire human form. The gods, whose true form
is human, can inhabit any form.

Neizvestny. *A Stone Resembling a Woman*. Drawing. 1965

Each mythological or religious system is explicable in terms of its socio-historical context. But all such systems begin with the stuff of the contradiction between the diversity and extension of the human imagination, on the one hand, and the recognized, limited specificity of the individual human body on the other.

Christianity with its emphasis on the uniqueness of the individual soul prohibited the two-way traffic, which only continued in witchcraft. But at the same time, by its concepts of heaven and hell, it stimulated a new metaphorical view of the human body. This body, according to the qualities of the soul within it, could enjoy eternal bliss or suffer eternal punishment. The latter received more attention because of the social needs for a prohibitive rather than permissive religion. Hell became the materialization of sin as a form of physical suffering. The reason why Dante's *Inferno* has inspired Neizvestny so deeply (see pp. 86–93) is that in it Dante describes in the most intricate detail the form of physical suffering befitting each sin. The bodies of the damned in the nine circles of hell suffer modifications so as exactly to express the quality of their sins. The *Inferno* is – among other things – an extraordinary work of symbolic anatomy. In it eternity and the Will of God give Dante the freedom to transcend the human body as it is seen objectively and to present *as eternal fact* how it feels – or suffers – subjectively.

The traffic between the human body and exterior nature is maintained – or rediscovered – as a principle by rationalism. Thus Diderot wrote:

Feeling and life are eternal. That which lives has always lived, and shall live endlessly. The only difference I recognize between death and life is that at the moment you live in the general mass,

and that dissolved, dispersed into molecules, twenty years from now you will live in detail.

Modern science suggests that the frontier which the 'traffic' crosses and recrosses is a false one – hence our previous need for the traffic. J. Z. Young, the biologist, writes:

In some sense we literally create the world we speak about. Therefore our physical science is not simply a set of reports about an outside world. It is also a report about ourselves and our relations to that world, whatever the latter may be like. . . . With the development of electrical tools it became possible to make measurements of very large and very small quantities. The result of these measurements have given further evidence that our naïve way of talking about a world distinct from man and divisible into pieces of matter enduring in time is not adequate.*

We can now begin to distinguish the context of experience to which the 'interiority' of Neizvestny's work must be related. The context is hard to define and so may seem obscure and remote. But as undefined experience it is familiar and universal. We are all aware that life fills our bodies with meaning: and that other bodies contain other lives which amount to more than the existence of all the body's parts. This is why, on reflection, it is difficult to kill; and why all premeditated murders are an attempt to destroy a presence rather than to put an end to a body. It also explains most suicides. Only very rarely is a suicide committing an act of aggression against his own body: what he wishes to put an end to is the meaning of the world that it contains.

Does the interiority of Neizvestny's work relate to 'the inner life' of the psyche or of the body? The answer is both.

* *Doubt and Certainty in Science.* Galaxy Books, O.U.P. New York, 1960, pp. 108–9.

His work has nothing to do with autopsies or individual psychological analysis. He is concerned with neither viscera nor complexes. He is concerned with creating an image of man that celebrates his total nature. His aim in this respect is the same as that of classical or Renaissance sculptors. But – and always with the extraordinary exception of Michelangelo – these sculptors accepted the human body as something complete in itself, its exteriority reflecting its permanent inner meaning; whereas Neizvestny sees the human body as *incomplete* and, beneath the superficiality of its approximate appearances, in a state of constant adaptation.

There is nothing original about Neizvestny's view. On the contrary, as I have tried to show, it is a constant of popular experience – often revealed in metaphor. It was a view shared by eighteenth-century Rationalists and nineteenth-century Romantic poets. Today it corresponds with certain commonly held scientific concepts. Neizvestny's originality lies in his expressing such a view in sculpture.

There is a well-known poem by Pushkin called *The Prophet*.

A six-winged seraph appeared to me at the crossing of the ways. . . . He bent down to my mouth and tore out my tongue, sinful, deceitful and given to idle talk; and with his right hand steeped in blood he inserted the forked tongue of a wise serpent into my benumbed mouth. He clove my breast with a sword, and plucked out my quivering heart, and thrust a coal of live fire into my gaping breast. Like a corpse I lay in the desert. And the voice of God called out to me: 'Arise, O prophet, see and hear, be filled with my Will, go forth over the land and sea, and set the hearts of men on fire with your Word.' *

* Literal translation by Dimitri Obolensky. *Penguin Book of Russian Verse*, 1962.

This poem offers us several clues about Neizvestny's imagination.

The symbolic incident described in it resembled Neizvestny's actual experience on the battlefield. With a coal of live fire in his gaping breast he lay like a corpse in the desert. As a result of this experience his view of life was transformed. Death became a starting point.

But it was not death in the abstract: it was his own death. Consequently it is, above all, through his own body that he is so keenly aware of life. It would be wrong to suggest that his art is autobiographical. He is not concerned with his own life story. Temperamentally he is more extrovert than introvert. But he senses that, given the starting point of death, it is through the self-consciousness and will to live of his own body that he can come closest to grasping a universal experience. Alive instead of dead, he represents man. He sees all figures from within – as though he inhabited them, or rather as though his body were interchangeable: differences of sex, age, personality are no more than differences of expression on a face. To be among the living is to be the living.

This attitude, which is perhaps better described as a compulsion for he did not choose it any more than the prophet in the desert chose to meet a six-winged seraph, is demonstrated and confirmed by his working methods. For a visual artist, he depends very little on his eyes. When he is modelling in clay he relies upon touch. One might suppose, watching him, that he was blind. When he is drawing, vision inevitably becomes more important, but only as a coordinating force of the impulses which come from his body or arm or hand.

Most revealing of all is the total method he has evolved for producing many of his sculptured figures (a method

which he might never have arrived at had he not been forced to do his own casting). He models the figures in clay, sometimes in wax or plasticine; next, he makes moulds from them. Then he reworks these moulds, often changing them profoundly, *from the inside*. Finally from the transformed mould he casts the figure, either in metal or in plaster. The first clay figures tend to be considerably closer to natural appearances than the finished casts. Thus the formalizations, distortions, omissions, exaggerations, additions are all made *from within the figure*, in negative. The final exterior surface, never seen until the cast is disclosed, is not the direct object of his working but only the consequence of the interior events he has imagined. Nothing else could demonstrate more vividly how such figures are his imagined habitations. 'I can work from inside the body instead of from the outside, and what will be the exterior surface of the bronze feels no farther from the centre of me than my own skin.'

A recent large sculpture by Neizvestny (about which critically I have many reservations) is called *The Prophet* and is a kind of translation of the Pushkin poem, although, curiously, the parallel did not strike Neizvestny while he was working on it. The difference of interpretation between the two works is that in the sculpture the prophet appears to have made himself. There is no seraph. It is the prophet's own hands which are thrust through the gaping hole of his own breast.

The poem describes a man being transformed by the entry of foreign bodies or elements into his own. He is a man re-made with new parts and yet still a man. This kind of transformation occurs again and again in Neizvestny's work.

It appears first in his wounded soldiers – in which the intrusion of something extraneous to the body is marked, as

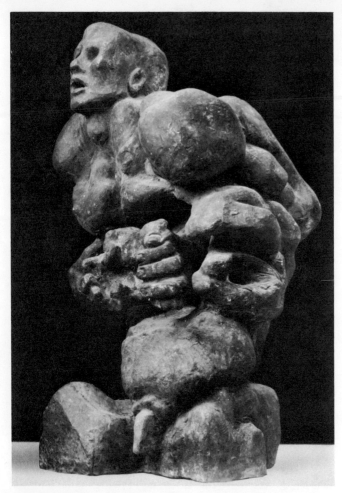

Neizvestny. *The Prophet*. Bronze. 1966

from the outside, by the wound or the hole. From these figures and from the *Man with Artificial Limb* there developed a series of so-called *Machine Men* (see pp. 118, 176). They are no longer seen from the outside. Their interiority is disclosed and we see that their bodies include and accommodate machine parts, or parts which look machine-made.

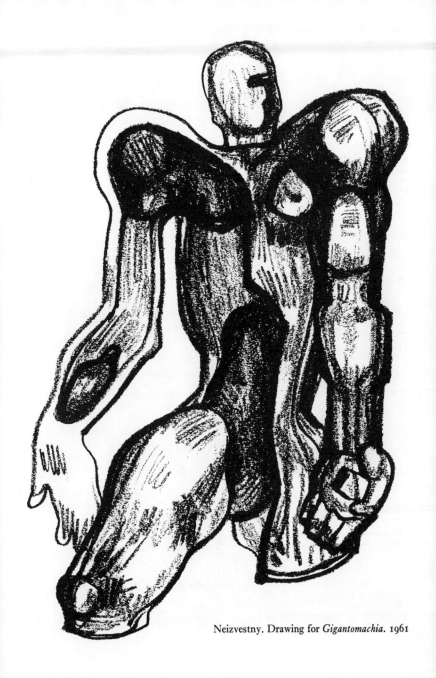

Neizvestny. Drawing for *Gigantomachia*. 1961

Neizvestny. *Machine Man*. Bronze. 1961–2

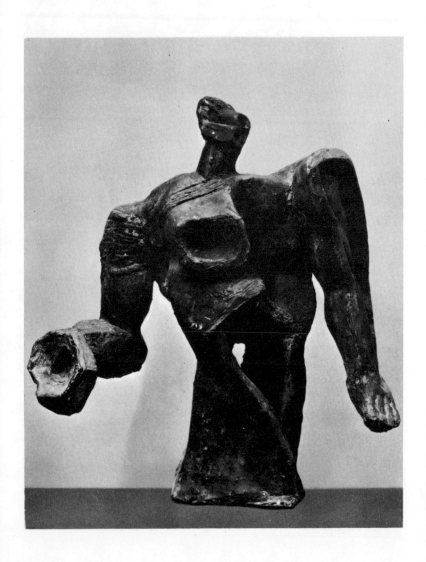

From these *Machine Men* there developed a series of *Giants*. Neizvestny had already had the idea that all these figures might one day be assembled together to make one work which he called in his own mind a *Gigantomachia*. With the giants the added parts are no longer so mechanical in form.

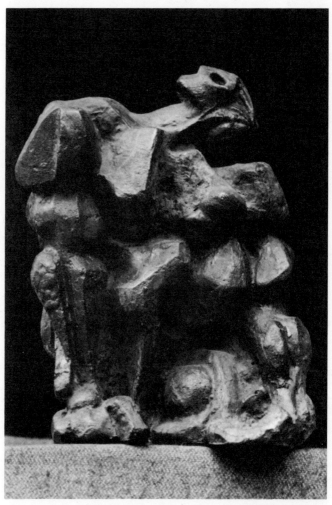

Neizvestny. *Two-Headed Giant with Egg*. Bronze. 1963. Photo: Mohr

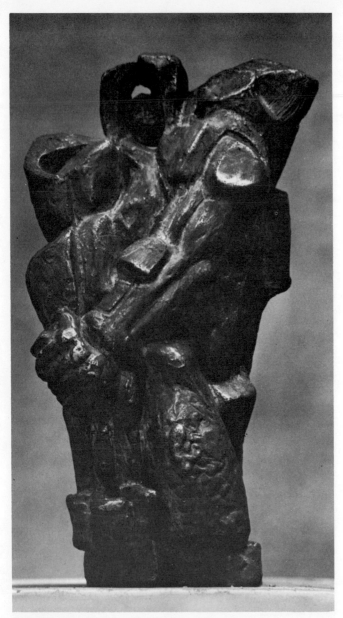

Neizvestny. *Giant's Torso*. Bronze. 1966

But it is clear that each figure has nevertheless adapted itself to and fused with new elements or parts which were originally separate from its own life. One of these sculptures is actually entitled *Figure with Another Sleeping Inside It* (see p. 170).

There is scarcely a work by Neizvestny which does not refer to the same idea which is treated metaphorically in Pushkin's poem.

The result of the transformation of the body by addition or subtraction may be a hermaphrodite, a centaur, a minotaur. The most 'natural' example is the bronze of a *Woman and Foetus*; one of the most violent examples is the drawing inspired by Dante of the suicide in the Forest of Suicides with a tree growing through her (see p. 124).

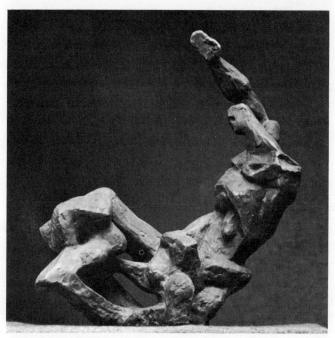

Neizvestny. *Centaur*. Bronze. 1965–6. Photo: Mohr

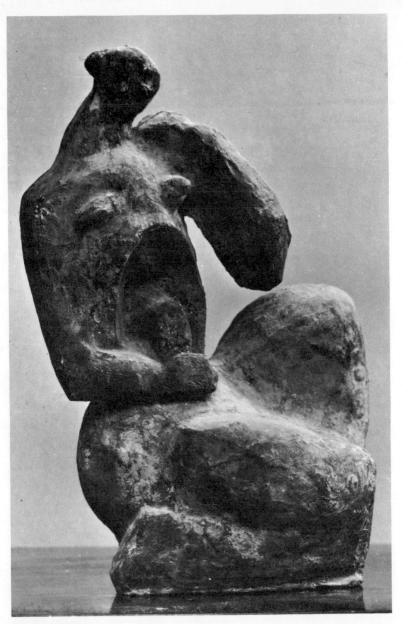

Woman and Foetus

Neizvestny. *Minotaur*. Drawing. 1966. Photo: Mohr

Neizvestny. *Woman Suicide*. Drawing. 1966

Yet Neizvestny's most profound and evocative works are none of these – in which a definition of man's contradictory, extensive nature has already been given by existing myths or knowledge. The centaur for us is already a fabulous beast – we no longer see him as a comment on the nature of man. It is true that Neizvestny's centaurs do their best to remind us that they are such a comment: they are not presented as complete creatures in themselves; we see them as the sum of a spontaneous, organic process of addition. Nevertheless the total is an idea with which we are already familiar – the centaur, the man–horse, the mythical beast of classical literature. His hermaphrodites (see pp. 171 and

180) are more effective because they refer more directly to a living experience: a hermaphrodite is the creature of coupling, the woman acquiring a penis, the man a womb. But even so, the concept of the hermaphrodite is too established to contain the *unexpectedness* which accompanies the living, momentary metamorphosis.

His profoundest works defy explanation by resort to any established concept. They remain – like the experiences which they express – mysterious. (Dependence upon established concepts causes the failure of all over-literary works – the failure of over-explicitness.) Examples of such works are the etching of the reclining woman whose head is surrounded by four heads turning on her neck like a wheel on an axle; the sculptures of *Adam* (see p. 172); *The Stride* (pp. 164 and 165); the *Giant's Torso* (see p. 185).

Neizvestny. *Reclining Woman*. Etching. 1967. Photo: Mohr

If it were the function of criticism to explain and decode the meaning of these works precisely and completely, criticism would amount to no more than the sabotage, the destruction of art. Or, to put the same proposition in a different way, it would mean that the works in question were not truly prophetic, but were merely an illustration of the already formulated and known.

It is worth recalling here an observation of Lévi-Strauss discussing the nature of the image as metaphor:

Images cannot be ideas but they can play the part of signs, or, to be more precise, coexist with ideas in signs and, if ideas are not yet present, they can keep their future place open for them and make its contours apparent negatively.*

In these works by Neizvestny images are keeping open the space of future ideas. It may not be immediately obvious because, at first sight (as we shall discuss in Part 3), the style of these works seems familiar and old-fashioned. Yet this is where it is easy to be deceived. The vocabulary and syntax of Neizvestny's art were first established at the beginning of this century: but Neizvestny is using and adapting this language to say something new about man's image of himself through the metaphors he finds in the workings of his own body.

Rather than try to define this image categorically, it may be more useful to show the direction of its meaning by a different but roughly equivalent example.

Take a cornfield in the wind, seen from above. The wheat is tawny-coloured like the wheat in June on the Polish plains. Across it waves of shadow follow waves of light. The shape of these waves and their movement must be

* English translation, *The Savage Mind*. Weidenfeld & Nicolson, 1966, p. 20.

governed by the height, weight and pliability of the blades beneath the wind.

How to explain that this sight is so evocative of love?

The way the wheat is ruffled is reminiscent of hair. The yielding of the wheat, revealed by the waves of light and shade, is reminiscent of the softness and resilience of thighs or shoulders: of the way that flesh under the pressure of a finger yields to form a very slight declivity whose edges – if one can speak of an edge marking the beginnings of such a tentative incline – advance or retreat as the finger moves.

Just above the knees, around the hips or across the stomachs of many women there are often tiny pale gleams or flecks in the skin. They are the colour of the germ of pearl barley, lighter than the rest of the body. The relation between the tone of these light flecks and the tone of the skin around them is identical with that between the light and the dark waves which traverse the wheat.

Each of these metaphorical explanations is based upon a correspondence between visual elements of appearance. A more profound explanation, closer to the manner of Neizvestny's thinking, might be as follows:

The imaginary surface, parallel to the earth and formed by the tips of the ears of wheat, the surface which the wind disturbs and inscribes waves upon, the surface which shivers and is smoothed out again, which gathers in excitement and is laid out concerted once more, this surface on which the tracks of excitement, of horripilation, are usually curved and serpentine, this imaginary surface represents diagrammatically the sensations felt on the touching surface between the bodies and limbs of two lovers. Each hair of each awn of wheat is a nerve-end. The wind is the touch of the other. The waves of light and shade are waves of repulsion and response. Both are the wheat and both are the wind.

The figure of the *Reclining Woman* has been transformed, by additions, subtractions and the establishment of inner, contradictory polarities. It might be possible to construct a description which appeared to fit the work. The description might refer to stones, geological formations, the growth of wood, machine parts, rockets, eggs, phalluses, beaten metal, silk, chemical precipitates, etc., etc. But all this would confuse and belittle the meaning of the work rather than illustrate and isolate it. In works like this Neizvestny is concerned with processes, with principles of being which have no singular meaning and whose pluralistic one cannot be reduced to a random selection of particularities.

Have I not now argued myself into an impossible position? If on one hand I suggest that Neizvestny's works are indescribable, how can I, on the other hand, claim that he is an epic, public artist? Is it possible to have truly public monuments which are mysterious, problematic or obscure?

We must distinguish between the detailed interpretation of a given work and its underlying theme: a theme which is likely to recur in a large number of the same artist's works. It is by virtue of the underlying theme of Neizvestny's work that he can be considered an epic or public artist.

Most artists during their lifetime have only one or two underlying themes, although they may work on many different subjects. Thus, for example, Renoir's theme was the aftermath of sexual pleasure; Rembrandt's theme was the process of individual ageing. These themes for the artists concerned amount to obsessions. They are the initial experience which fires and continues to fire their art. Their art is a continual attempt to give meaning to this experience. Neizvestny's theme is the theme of endurance.

We have seen how his starting point is death; how, given this starting point, he is especially aware of the obstinacy of life; how this obstinacy is created and maintained by the constant need to adapt to and contain contradictions; how he metaphorically visualizes these contradictions as forces and events internally modifying the structure and workings of the human body. All this leads to his figures becoming models (in the scientific, not the moral sense) of endurance.

A chain is as strong as its links. A machine – or an argument – is as strong as its parts. But man is stronger than most of his parts, and may one day become stronger than any of them. He can survive subtractions and additions. By comparisons with him all his artefacts and even his institutions are absurdly delicate. Yet his strength derives from a power which paradoxically is inseparable from his susceptibility: his will. Such is the theme of Neizvestny's art.

We must now ask what significance this theme can have in the world at large.

Courage is one way of responding to threats and to suffering. In so far as it is witnessed or recognized by a second person, it offers an example. Those who offer examples of courage are considered heroes. Each society and each class in that society selects its own heroes according to its own experience and needs. But until this century most heroes demonstrated their courage in a similar way: by deliberately risking their lives. Portraits or accounts of these heroes or their heroic actions tend to emphasize the nobility and the inspiration of the moment of decision, the moment of joining battle – regardless of the result. It is a moment of danger, but it is also a moment of privilege, of honour: the moment of the 'happy few' at Agincourt.

> And gentlemen in England, now a-bed,
> Shall think themselves accursed they were not here
> And hold their manhoods cheap whiles any speaks
> That fought with us upon Saint Crispin's Day.

Other more passive forms of courage have always existed, but they were seldom celebrated, because the risks or suffering involved were considered natural and inevitable (e.g. that women should lose their husbands in war, or that the poor should die in famines).

The same ideal of courage persisted long after Agincourt. It was the ideal with which millions enlisted to fight on the Western Front in the First World War. There the ideal crumbled before a new reality.

Today we are aware of unnatural suffering existing on an unprecedented scale. This is partly the result of our ability to organize and inflict suffering to a qualitatively and quantitatively new degree owing to the existence of modern weapons, concentration camps and organized policies of genocide. Partly it is the result of our knowledge that much of the suffering that is not directly inflicted is nevertheless unnecessary: that its causes are economic, political and social.

The extent of this unnatural suffering, recognized as unnatural, has changed the concept of courage. It can no longer be the prerogative of a happy few at certain chosen moments: it is a necessity for millions in a continual state of resistance. Twenty million Russians were killed in the Second World War before the Nazi armies were beaten. The Vietnamese people have been fighting for their independence for twenty years and are prepared to fight for another twenty. We can no longer think of courage in terms of exceptional deeds or heroic moments of personal decision. Courage becomes the obstinacy of victims who

resist their victimization: it becomes their ability to endure until they can put an end to their suffering.

Today the hero is ideally the man who resists without being killed. Cunning as the mental faculty which is the equivalent of endurance has become, not the better part of valour, but certainly an essential part.

As with all ideological changes, this change in the meaning of courage is closely interrelated with other changes.

We noticed that the traditional view of courage linked the quality with the hero's free choice. The notion of human courage is closely associated with that of freedom. It is freedom that gives meaning to courage.

The majority of the world is now engaged in struggling for a freedom which was inconceivable before the nineteenth century: freedom from exploitation: the freedom for all to live as the equal beneficiaries of the world's material and spiritual production. The struggle must go through many phases. It begins as a struggle for a single national, racial or class freedom from imperialist exploitation. But this new freedom has already outdated and destroyed the older notion of freedom as an individual privilege – and hence also the notion of the privilege of individual heroics.

Events force us now to admit the courage of a people or a class: not the courage of a people as represented by their professional armies, but made manifest in the actions of the entire population, men and women, young and old. The truth of this is realized by military strategists if not by moral philosophers. The strategy of total war recognizes that it is necessary to try to break the courage and resistance of a whole people.

The courage of a people or class is not proved by their risking their entire existence: on the contrary, it is proved by their endurance and their determination to survive. Che

Guevara in his first published statement after he had left Cuba in 1965 to organize and participate in revolutionary guerilla movements in Latin America, wrote:

All the oligarchies' powers of repression, all their capacity for brutality and demagogy will be placed at the service of their cause. Our mission, in the first hour, will be to survive; later, we will follow the perennial example of the guerrilla, carrying out armed propaganda (in the Vietnamese sense, that is, the bullets of propaganda, of the battles won or lost – but fought – against the enemy). The great lesson of the invincibility of the guerrillas taking root in the dispossessed masses. The galvanizing of the national spirit, the preparation for harder tasks, for resisting even more violent repression.*

A guerilla leader in Guatemala expresses the same thought: 'We must think of our fight as a long and exacting struggle which may perhaps last ten years or twenty. Our first aim is to continue, to endure – and for that to survive.'†

The example of endurance is being changed from a passive to an active one. It applies no longer to an individual form of stoicism but to a collective determination to survive and to attain the conditions of living in freedom.

Such is the context in which one must place the obsessional theme of Neizvestny's art. And the context helps to re-explain the form and manner of his art.

It is impossible to express the positive role of endurance in terms of a body's exterior appearances. The figure becomes a victim or a man undergoing a trial – like Job. Or else he has to be presented as already victorious. It is impossible because the positive role of endurance cannot be demonstrated by any single act, event or outcome. The role

* *New Left Review*, no. 43, p. 88.
† Quoted by Jean Lartéguy, *Paris Match*, 26 August 1967.

is essentially a dialectical one of process and growth, transcending the individual case. It is nothing less than the human power to continue.

All the static truths of yesterday are today only half-truths . . .

Neizvestny. *Three Dancing Figures.* Drawing. 1966. Photo: Mohr

3.

To assess Neizvestny's work, to attempt a critique of it . . .

If, knowing nothing about Neizvestny, one looked quickly at the plates in this book, one might assume that the works dated from just after the First World War. There are stylistic affinities with certain works of that period by Lipchitz, Zadkine, Gargallo, Gaudier-Brzeska, Epstein, Duchamp-Villon. The influence of Henry Moore would be a little puzzling, for it would seem to come mostly from the Moores of the late 'forties. But probably one would dismiss this as a coincidence rather than an influence. By and large the idiom is that of 1915 to 1925. And one might assume that the artist was then in his forties. Works like *Orpheus* or *The Prophet* (see pp. 139–40 and 116) suggest the earlier influence of Rodin or Bourdelle, who presumably impressed him during his youth in the 1890s. Thus, judged by current standards in Western Europe, Neizvestny's work is apparently forty years behind the times.

Some may be tempted to explain this as a consequence of the forty years 'wasted' under Stalinist academicism. It would be a neat theory but there is only a small element of truth in it. It is true that since the late 1930s Russian artists have been at a disadvantage in that they have only been able to follow developments in art in the rest of the world through books, magazines and photographs. No important work of twentieth-century sculpture has ever been seen in the Soviet Union. But it seems that this disadvantage is not crucial. There are other unofficial artists in Moscow whose work belongs unequivocally to the 1960s. The time-lag is not an inevitable consequence of the recent history of Russian art.

It would be nearer to the truth to suppose that Neizvestny has chosen the style of 1915–25 as the most developed style available for his purpose. Developments in

sculpture since 1930 have, roughly speaking, been in one of two directions: either towards new forms of abstraction – Adam, Calder, David Smith and others; or towards idiosyncratic, highly personal statements of despair, opposition or fantasy – Arp, Etienne Martin, Germaine Richier, César, Tinguely. Neither direction promises much to a monumental figurative sculptor.

One might expect such a sculptor to be interested in Henry Moore, and in fact Neizvestny admires Moore a great deal and has undoubtedly been influenced by him. Yet the influence has been limited because their temperaments as artists are so dissimilar. Moore's imagination is oceanic: his figures are the creatures of forces that overwhelm them. His world, although his sculpture is entirely unliterary, is not unlike Thomas Hardy's. Neizvestny's imagination, as we have seen, is anthropocentric and based on a heroic conception of the human will.

The post-war work to whose spirit Neizvestny is closest is Zadkine's Monument to Rotterdam, and it is significant

Zadkine.
Monument to Rotterdam. 1951

that in this work, which is the most successful figurative sculptural monument of the last twenty-five years in Western Europe, Zadkine has used a sculptural language which derives from the same period of the early 1920s.*

Yet is not all this begging the question? Is it not quite simply possible that the figurative sculptural monument in bronze has become outdated? Would not Tatlin or Lissitsky have considered Neizvestny's work 'old-fashioned' forty years ago?

There is no doubt that they would have done. And monuments in the future may well be made of very different materials in a very different spirit. Yet here we must not be misled by a theory of obsolescence borrowed from the consumer-goods market and applied to art. (As the turnover on the art market becomes quicker and quicker, this is a problem that increasingly bedevils criticism.)

Consumer goods are artificially rendered obsolescent by each new model being given a different 'look' from the preceding one. The content usually remains the same. The 'look' is arbitrary in relation to the content; its only meaning lies in its difference from the previous look. Thus, in the case of consumer goods, 'form' or 'style' must, if it is to exist at all, kill its predecessor.

In a successful work of art, form and content are inseparable. The 'look' is not arbitrary. Yet one cannot generalize about this unity of form and content. It is always a special achievement in a particular work: and its uniqueness is its value.

A style in art mediates between form and content. It offers a method and a discipline to apply to the search for unity. It is not a formal quality but a way of working.

* For a fuller analysis of Zadkine's monument see the author's *Permanent Red* (Methuen, 1960).

A new style in art evolves – if it is not artificially stimulated – to meet the problem of treating new content born of social change. At first the style appears to be unrestrictive and open to all possibilities – that is to say it appears to be qualitatively 'modern': not because it is new in itself, but because it can admit new content. Gradually, with the passing of time and as a result of the success of its mediation, as a result of its now appearing to guarantee a unity between form and content (which in fact will turn out to be a spurious formalistic one), it tends to oppose the admission of further new content.

The further new content then demands a further new style. But this new style does not necessarily render the former one obsolete for ever. On the contrary, the new style by its initial opposition may start a process which leads to the liberation of the former style from its latter-day formalism. The new style releases a new content and this new content, when it has become more complex by being assimilated, may re-find its more complex expression in a liberated version of the former style.

The history of art, in the period of revolutionary change which began at the start of the nineteenth century, is not a successive battle of styles, but a constant interaction between styles caused by the developing social reality seeking ever wider and more complex expression in art as content.

If one wishes to judge whether an artist's work is of its time or whether it is a mere imitation or repetition of what has been done in the past, one will be hopelessly misled if one concentrates upon the question of style.

There are two questions which must be asked:

1. What is the presumed generalized content of his work and how relevant does this seem to the experience of the changed world?

2. Considering each work separately, is there a unity between content and form?

Neither is an easy question to answer, but they are the logical ones.

Let us now ask these two questions about Neizvestny's work. The first has, in effect, been answered. We have examined the presumed content of Neizvestny's work and its relevance to the emerging modern world. If this were the only criterion for judging an artist, Neizvestny would be one of the most original and significant artists working today. But there is the second question. To answer this we must distinguish between the presumed content of his work in general and the manifest content of particular works.

There are works where the manifest content is badly flawed and fails to do justice to what we can presume to be his intentions. Examples of such flawed works are the sculptures of *Orpheus* and to a lesser extent *The Prophet*, or the etching from the Dante series (see next page).

Neizvestny.
Orpheus. Zinc alloy. 1962–4

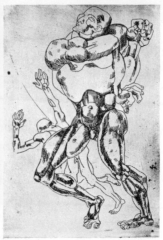

Neizvestny. *The Prophet.*
Bronze. 1966

Neizvestny. *Figure in Hell.*
Etching. 1966. Photo: Mohr

Such works are, in the negative sense of the term, rhetorical. This is a question of a failure of form. The forms cannot contain and hold the emotions they suggest. The emotion and the meaning escape them – to importune and nag at the spectator. They are appeals rather than statements (the same is true of a great deal of modern Expressionist art) and the trouble with such appeals is that they are always addressed to an already established response. They are finally based on the proposition that 'once it wasn't like this': they are essentially nostalgic.

In the formal failure of these works we find a nostalgia equivalent to the emotional one. The forms that cannot contain the emotion they suggest are forms borrowed from other artists and then not transformed by assimilation but merely exaggerated. They become melodramatic gestures.

Thus: the shoulders and arms and hands of *Orpheus*; the facial features of *The Prophet* (remove the head of this

sculpture and the figure is totally changed for the better); the whole conception of the etching.

The forms have been borrowed from Michelangelo, Rodin and their lesser imitators. And they have been borrowed for their piecemeal effect. It is significant that when this flaw occurs in Neizvestny's work, it invariably concerns a hand or a head – the most naturally expressive parts of the human body. The weakness derives from an impatience on Neizvestny's part to affect the spectator emotionally: an impatience to establish his point of view *through* a work of art instead of *in* it. Against all his wishes, works which are flawed like this become monologues from the artist to the spectator. The spectator must either accept the message or reject it: there is nothing *in* the work for him to approach; the work is only a constant flux of effect towards him.

One sees a similar impatience hindering Neizvestny's imagination in certain projects he has made on his own initiative for official monuments; for example, the *Cosmonaut*.

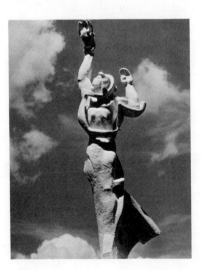

Neizvestny. *Cosmonaut.*
Plaster. 1961–2

The impatience here is not emotionally directed at the spectator. But the work is conventionalized because the artist is impatient to have a project accepted and realized, to see a sculpture constructed on the scale he dreams of, to begin his dialogue with a large public.

Given this situation, both kinds of impatience are entirely understandable. They are the result of his isolation as an artist. They amount to an impatience to reach the spectator, emotionally and civically.

Yet, however understandable this impatience, its result must be considered in terms of his art a serious weakness which it is necessary for him to overcome. Not for any inflated reasons about his 'individuality' as an artist, but because the effect on his art is in direct opposition to his actual achievement in many works and his potential achievement in others.

We have seen that the originality and meaning of his best figures are to be found in their interiority. It is here that Neizvestny becomes significantly inventive. Yet the short-cuts he takes as a result of his impatience lead to the most superficial *exterior* gestures and expressions.

The forms become inadequate for the presumed content. The notion of a giant, instead of being metaphorical, becomes literal. We see a body immobilized, or at least greatly slowed down, on account of its size and the magnitude of the drama thrust upon it. The contradictions and adaptations, the energy of the events occurring within the figure are hidden by a kind of blanket of purely exterior expressiveness thrown over them. Even where one can make out the vague shape of some inner event, it only becomes part of the monolith of appearances. The sculpture becomes drama-bound as a figure is muscle-bound. Such is the consequence of his impatience.

Let us now consider some examples of his work in which there is a unity of form and content.

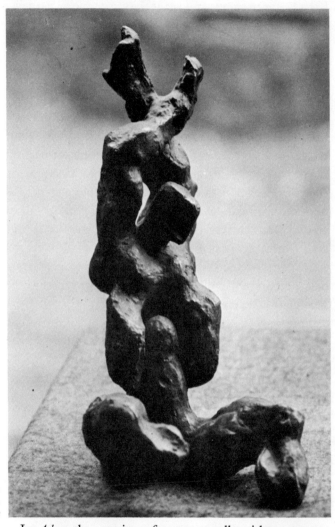

Neizvestny. *Adam.*
Bronze. 1962–3.
Photo: Mohr

In *Adam* the exterior references, totally without expressive drama, are sufficient for us to 'read' the sculpture as a man: the forms in their interior relations with one

another and with space present this man as a *process*. He grows. He is like the magnolia tree in bud: his crossed arms like a flower opening. And yet at the same time he has none of the fragility of a flower. He is equally like molten metal that has suddenly set in its flow. Yet he has none of the rigidity of metal. The similes can never be adequate. He is man, evolution become conscious of itself, more sensitive than a flower, more enduring than any other species.

The meaning of the forms – if we mean by that the conscious and unconscious evocations they produce in our minds so that we can wordlessly define and remember them – is predominantly sexual. The erect member between the legs is both spine and penis. His right thigh is tumescent like another member, the ring of its gland swollen. The thrust and the delicacy of the figure as a whole (and something similar applies to many of Neizvestny's works) suggest those sensations of density, weight, lightness, containment and flowering which are very close to the sensations of an erection.

This is not to say that Neizvestny is specifically an erotic artist. Eroticism, on the level at which it is generally understood in the visual arts, is as superficial as nudity. Neizvestny is not interested in nudity and he is not interested in artificial sexual provocation. What interests him is the opposite – the natural, central inextinguishable power of sexuality.

This power, crudely itself or sublimated and mediated in many different ways, is the energy of endurance. Thus if endurance is to be shown, not as a moral attribute, but as a biological and social force, the appropriate sculptural forms are likely to be sexual by association and in origin. By means of his interiorization of the body, Neizvestny places a value on sex which is in total opposition to the aphrodisiac value of

Neizvestny. *Woman and Phallus*. Monotype. 1960

commercialized sex. For the latter, sex is reduced to
aesthetics. For Neizvestny sex is, above all, a form of energy.

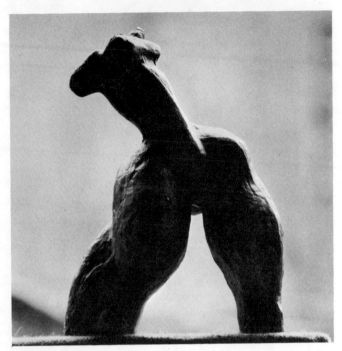

Neizvestny. *The Stride*. Bronze. 1960. Photo: Mohr

The Stride is the torso of a woman moving forward: but
at the same time, without any visceral naturalism, it is an
organ functioning. (Not necessarily a sexual organ, or, for
that matter, any actual or specific one.) Its forms are such
that they suggest a pulse to sustain the effort of its function.
It is not enough to say that these forms are organic as
distinct from inorganic; they are biological.

What I have termed Neizvestny's interiorization of the
body need not necessarily mean disclosing the interior of
the body as such: it can equally well mean extraction from
the body.

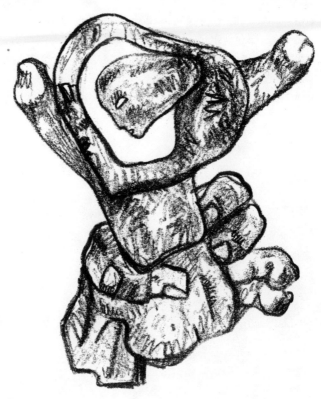

Neizvestny. *The Hand*. Drawing. 1961

In the drawing of *The Hand*, the hand holds or is joined to emblems of a heart, an embryonic head and a penis.

We must be clear about the advantage and dangers of such a method. It can easily lend itself to vulgarization. There is nothing to be gained – except a sensational *frisson* – from displaying entrails. And if this were the measure of Neizvestny's originality, it would not be worth considering.

What Neizvestny has begun to find in a work like *The Stride* is a new mode of formalization. His simplifications and distortions, unlike those of Michelangelo, have little to do with the body's visible infra- and superstructure;

equally they have nothing to do with the pathetic attitudi-
nizing of Expressionism or with the pursuit of pure form
which hopes to arrive at certain formal archetypes which
can apply to all structures and events; instead they grow out
of an awareness of the biological unity of all the parts of the

Neizvestny. *Hermaphrodite Torso*. Zinc. 1966. Photo: Mohr

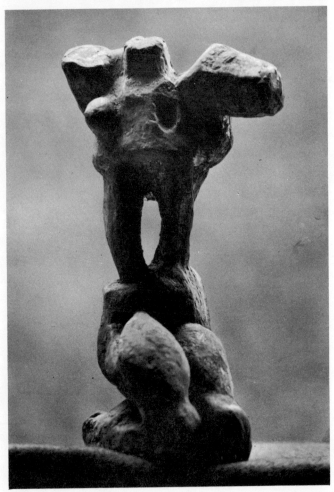

body, the invisible and the visible, the muscular and the electrical, the vital and the mortal. The possible ways of development for Neizvestny as an artist all begin at this point. It is the point at which the physical nature of man can be seen to contain his universe and the point at which contradiction can be seen to be the condition of life.

The *Hermaphrodite Torso* is a more complex and less seductive work than *The Stride*. It is an assembly of limbs and parts – a man's legs, a womb of space, a woman's breast, the shoulders of a machine. Unlike the *Adam*, this has little to do with the affirmative pleasure of sex, but far more to do with the sensation of effort, with the struggle for survival. As the variation of its parts suggests, it transcends the individual. If the terms had not all been abused in the usage of false moralities, I would say that it represents – but in terms of the fantastically resilient and vulnerable human body – the family, the nation, the human race. Its polarity, as always, is taut between life and death, between the breast and the cavity, between the tensed thigh and the rent abdomen. This is how men die in battle thinking of their children. This is how children are massacred before their helpless parents. This is what joins men together in resistance: a resistance which, if false ideologies are discarded and rendered undeceptive, we can find in the body itself.

All false ideologies rely upon a facile optimism: an optimism which denies the inevitability of contradiction, and therefore denies life itself. Optimism must always be specific. Exploitation can be destroyed. Contradictions should be the condition of life and development, not the cause of death and hopeless deprivation. But the only utopia is death, because it is without contradiction. Neizvestny, who knows death better than most, is well aware of this. Hence his *Man Restraining Himself*.

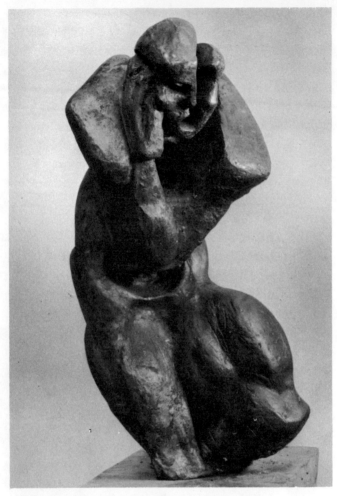

Neizvestny. *Man Restraining Himself*. Bronze. 1962–4

The man is divided against himself. The division can destroy him or create him. One thigh is triumphant, the other is withered. One arm exists, the other is amputated. Such is our condition, whether we recognize it or not. We need seek no explanation or consolation by recourse to God,

original sin or any other religious argument. In it we need only seek our opportunities. And the sculpture affirms this by its reference once again to an imagined organ within us, an organ remarkably similar in its overall shape to the actual, as distinct from the emblematic, shape of the heart.

Look finally at the human hand as Neizvestny sees it.

Neizvestny. *Hand*. Drawing. 1965

Its gesture is reminiscent of that of the hand of God in Michelangelo's *Creation of Adam* in the Sistine Chapel. But it is not the hand of God, made in the image of man. It is the hand of man made in the image of his scars, his labour, his machines, his intelligence, his will to live which is harder than rock, and his desires which are even more delicate than his anatomy.

I have often in the past made comparative and competitive claims for an individual artist, saying for example that X is the most important European artist since Y. It is a not entirely meaningless formula and it offers a tempting short-cut to the reader's mind. But I now believe it to be profoundly mistaken: not because there is a danger of the judgement being a wrong one – there are no absolute and eternally right judgements: but because the notion of competition has become alien to the spirit of art.

When the social position of the artist was that of an artisan or a super-craftsman, the spirit of competition acted as a stimulus. Today the position of the artist has changed. He is no longer valued as the producer of his work, but for the quality of his vision and imagination as expressed in his work. He is no longer primarily a maker of art: he is an example of a man, and it is his art which exemplifies him. This is true at an appreciative and philosophical level even under capitalism, where works of art are treated on the market like any other commodity. In the artist's new role there is no place for comparative competition. One cannot properly compete to be a representative of Man. It is the contradiction between this truth and the dominance of the art market over all art production which destroys so much talent and creates so much confused desperation among artists in the capitalist countries.

The only truthful and appropriate claim I would make for

Neizvestny's work is as follows: the best of his work reveals and expresses an essential part of the experience being lived by millions of people, more especially millions in the three exploited continents. They do not know of the work of Neizvestny. He does not live among them. But therein lies the gift of imagination, of prophecy. Or, to put it another way, therein lies the marvellous and inevitable interaction between the lives and events of what has become an indivisible world. Prophecy now involves a geographical rather than historical projection; it is space, not time, that can critically limit out vision. To prophesy now all that is necessary is to know men as they are.

The people of the three continents are involved in a struggle which they will never abandon until they have achieved their freedom: not the nominal freedom of independent States, but the freedom for which all others so far imagined have been a preparation: the freedom from exploitation. When they have achieved this freedom – and at the longest it will be within a century – they will produce art unimaginable by us today. Unimaginable by us today because the freedom they win may change the condition of man. Meanwhile some of Neizvestny's sculpture is an interim monument to the endurance necessary at the beginning of this struggle.

Is this how an essay on a sculptor's work should end? The sculpture being relegated to represent a phase in the world struggle against imperialism? I believe that nothing is more important than this struggle. It is to this that in direct and devious ways we should devote all our energy. For those who cannot do so the logical conclusion is suicide.

Let us be clear about why this is so. The present condition of the world, if accepted as it is, if approached with anything short of determined impatience to change it utterly, renders

every value meaningless. Two-thirds of the people of the world are being robbed, exploited, deceived, constantly humiliated, condemned to the most abject and artificial poverty and denied as human beings. Furthermore, if this condition is accepted – or even more or less accepted with the qualification that there should be a few reforms, a little restraint and a little more foreign aid – it is quite clear from the evidence to date that the condition will become even more extreme. Imperialism is insatiable. It can modify its methods but never its appetite.

Yet the situation is not so new. The plundering has continued for centuries. Why must one's reaction to it now be so violent? Why speak of suicide?

Because we have reached the stage where no justification of the world *status quo* is possible. Even the concept of justification falls apart. If we now choose to live in the world *as it is*, we must deny every purpose and every value which, as social beings, we have inherited: not only those we have inherited from Europe which European hypocrisy has made in so many ways suspect, but also those which we might inherit today when, either with us or without us, history is about to become universalized.

It is those who accept the world as it is who are becoming the disinherited at the same time as the dispossessed are rediscovering their inheritance. Disinherited, each finds himself isolated and alone, face to face with a hell that only death can end. That hell is the present condition of the world – if one is not engaged in terminating that condition The dimension of eternity which made the medieval vision of hell absolute is replaced in our terrestrial hell by the notion of the inevitable and absolute inequality of man. The torture within the absolute dimension of this inequality is not pain inflicted upon indestructible, always sentient

bodies but the pain of totally denying our indestructible, always pressing need for the recognition of ourselves in others. The torture is the existence of the other as an unequal.

Frantz Fanon, although he had no pity for it, understood the nature of this torture very well:

Leave this Europe where they are never done talking of Man, yet murder men everywhere they find them, at the corner of every one of their own streets, in all the corners of the globe. For centuries they have stifled almost the whole of humanity in the name of a so-called spiritual experience. Look at them today swaying between atomic and spiritual disintegration.

And yet it may be said that Europe has been successful in as much as everything that she has attempted has succeeded.

Europe undertook the leadership of the world with ardour, cynicism and violence. Look at how the shadow of her palaces stretches out even further! Every one of her movements has burst the bounds of space and thought. Europe has declined all humility and all modesty; but she has also set her face against all solicitude and all tenderness.*

Until comparatively recently the condition of the world was not intolerable. The conditions under which two-thirds of the world population lived were approximately the same as now. The degree of exploitation and enslavement was as great. The suffering involved was as intense and as widespread. The waste was as colossal. But it was not globally intolerable because the full measure of the truth about the condition was unknown. Truths are not constantly evident in the circumstances to which they refer. They are born – sometimes late.

* English translation, *The Wretched of the Earth*. Macgibbon & Kee, 1965. Penguin Books edition, 1967, p. 251.

Earlier, Europeans were able to deceive themselves by believing that they represented man at his most civilized, that the native was as yet only half-developed: thus they were not forced to abandon a final belief in equality, for the issue could be deferred while they created and exploited inequality. Earlier, the native was unable to come to terms with the scale of the crimes perpetrated against him: he experienced a kind of agoraphobia in face of his continent of suffering. Earlier, the utilitarians could argue that the available scientific and productive means were not sufficient to benefit all five continents.

Today nobody can be deceived. The truth has been born. Many try to forget what they know, but they never entirely succeed. 'Civilized' Europeans have proved within Europe that they are capable of systematic genocide. As a result it was necessary to draw up the Declaration of Human Rights to apply – in principle – everywhere. The world is now treated and considered as a single unit by military strategists, investors, intelligence services, scientists, philosophers; it is treated as a single unit for almost every purpose save the redistribution of wealth and the abolition of scarcity. Repercussions from events circle the world. (So do the images of these events: we cannot claim not to have seen the intolerable condition of the world.) Imperialism has become more concentrated and more blatant. The United States, which makes up six per cent of the world population, controls or owns sixty per cent of the world's resources. The military expenditure of the United States, necessary for the defence of these interests, annually exceeds all the national revenues of Africa, Latin America and Asia added together.

Yet it is not directly from these developments that the truth was born. It was born of the determination of the

exploited to fight – not even, to begin with, for economic justice, but for their identity: to rid themselves of the eternal foreigner, the *other* who had invented and imposed for centuries upon them his wretched doctrine of *otherness*, of hereditary human excommunication. The last need of imperialism is not for raw materials, exploited labour and controlled markets: it is for a mankind that counts for nothing.

The wars of national liberation already being fought and those that will be fought should not be idealized: they are wars of the utmost cruelty, inevitably involving a whole people without distinction between men and women, the old and the young: but we must understand what is involved.

Imperialism, despite its power and its resources, has become meaningless. It can no longer accommodate reality. Those who fight for it are kept nervous and energetic by the artificial development of pathological greeds – which is one of the reasons why they have little endurance. Those who do not fight for imperialism but acquiesce in it lead lives which become increasingly devoid of meaning – hence the spiritual decay of modern affluent societies. (I said that suicide was the logical conclusion of such acquiescence: but few behave logically.) By contrast, those who fight imperialism are fighting for all human meaning.

We have reached the stage of acquiring faculties – productive, scientific, cultural and spiritual faculties – which demand a world of equality. Either that demand is met or we deny our faculties and render our very being void.

Thus it should not be difficult to understand why I 'relegate' Neizvestny's sculpture to representing a phase in the struggle against imperialism. I have tried to show why, furthermore, his work may be pertinent to that struggle. If it is, the pertinence is not accidental. It reflects

both his own personal experience and a general situation in the U.S.S.R.

The example and the existence of the U.S.S.R. has been a crucial factor in the anti-imperialist struggle. 'The October Revolution,' said Lenin, 'has broken, in Russia, the weakest link in the chain of international imperialism.' Consciousness of this fact and of the revolutionary tradition attached to it has persisted in the Soviet Union. But sometimes this tradition supplies no more than an acceptable vocabulary with which its own betrayal is covered.

As soon as the policy of Socialism in One Country was established as a dogma by Stalin in the mid-1920s, the world revolutionary role of the Soviet Union was compromised. Isaac Deutscher describes the beginning of the process:

The Bolshevik bureaucracy now descended from the heights of the heroic period of the revolution to the bottomlands of the nation–state; and Stalin led it in the descent. They craved security for themselves and *their* Russia. They strove to preserve the national and, above all, the international *status quo*, and to find a stable *modus vivendi* with the great capitalist powers. They were convinced that they could find it in a kind of ideological isolationism, and were anxious to disengage the Soviet Union from the class struggle and the social conflicts in the outside world. In proclaiming Socialism in One Country, Stalin in effect told the bourgeois West that he was not vitally interested in socialism in other countries.*

It is not part of my purpose in this essay to argue whether at that time any but a defensive policy was possible. But what is certain is that the manner in which the Stalinist policy was imposed, carried out and ideologically justified

* *The Unfinished Revolution.* O.U.P., 1967.

hindered the subsequent development of any other policy even when circumstances had changed.

The national egoism of Stalin's policy was transmuted into personal egoism within the vast all-powerful bureaucracy which was established to exact and organize the superhuman national effort necessary to construct within the borders of the U.S.S.R. what amounted to an alternative world. This bureaucracy still remains. The revolutionary initiative of the people was curbed and diminished by the withholding of information and the discouragement of all discussion – both measures being justified in the name of the special security necessary for the defence of a world within a world. The initiative has not yet been won back.

In 1962 at the twenty-second Congress of the Communist Party of the Soviet Union it was announced that in the next twenty years there would be an increase of 350 per cent in *per capita* income: and that at the end of those two decades the Soviet people would be enjoying the highest living standard in the world.

This is an extraordinary tribute to the productive energy of a socialist country. But how does it relate to the demands we have been considering of the world taken as a whole? The question remains unanswered both theoretically and in policy.

And it remains unanswered because no bureaucracy can answer it and the answer cannot be imposed from above. It can only be answered by the Soviet people choosing to give their lives a fuller revolutionary meaning.

Nobody should underestimate the present Soviet contribution to the struggle against imperialism: but equally nobody can deny the contradiction between the original spirit of the October Revolution and the grave compromises

imposed by Stalin which still, more than a decade after his death, dominate a large part of Soviet policy.

Neizvestny has lived with the effects of what is basically the same contradiction in the field of art. Being the kind of man he is, it is certain that his experience has sharpened his awareness of the most profound and urgent reality to which the contradiction refers: the intolerable condition of inequality in the world.

Portrait of Ernst Neizvestny. Photo: Mohr

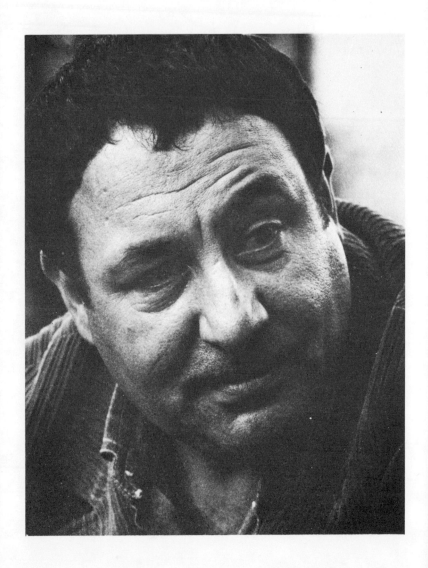

Plates

The Stride. Bronze. Height 30 cm. 1960. Photos: Mohr

Effort. Bronze. Height 54 cm. 1962. Photos: Mohr

Centaur's Torso. Bronze. Height 54 cm. 1961–2. Photo: Mohr

Two-Headed Giant with Egg. Bronze. Height 32 cm. 1963. Photo: Mohr

Figure with Another Sleeping Inside It. Bronze. Height 35 cm. 1966

Hermaphrodite Torso. Zinc. Height 38 cm. 1966. Photo: Mohr

Adam. Bronze. Height 23 cm. 1962–3. Photo: Mohr

Figure with Child Sleeping Inside It. Plaster. Height 57 cm. 1963.
 Photo: Mohr

Antipode. Bronze. Height 13 cm. 1957. Photo: Mohr

Kneeling Figure. Bronze. Height 25 cm. 1960–61. Photo: Mohr

Machine Man. Bronze. Height 50 cm. 1961–2

Crucifixion. Plasticine. Height 43 cm. 1966. Photo: Mohr

Woman and Foetus. Bronze. Height 30 cm. 1961

Construction of Man. Plaster. Height 60 cm. 1963. Photo: Mohr

Hermaphrodite. Bronze. Height 14 cm. 1963

All Clear. Bronze. Height 26 cm. 1957. Photo: Mohr

The Kiss. Bronze. Height 10 cm. 1963. Photo: Mohr

Two Spheres Inside One Another. Wax. Height 25 cm. 1967

Centaur. Bronze. Height 30 cm. 1965–6. Photo: Mohr

Giant's Torso. Bronze. Height 35 cm. 1966

Man Restraining Himself. Bronze. Height 70 cm. 1962–4

The Stride (front view)

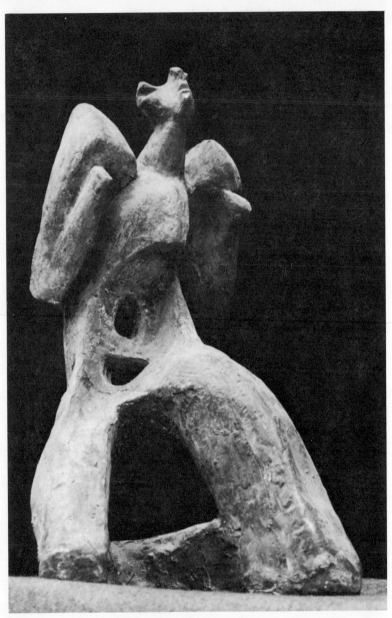

Effort (front view)

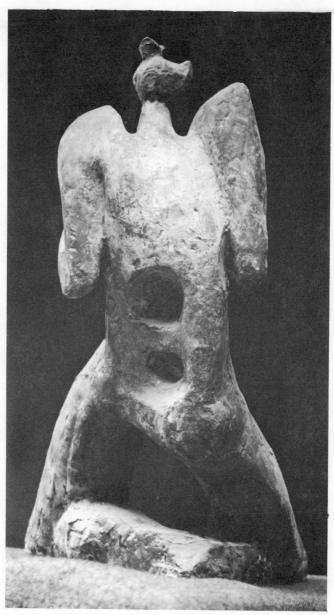

Effort (rear view)

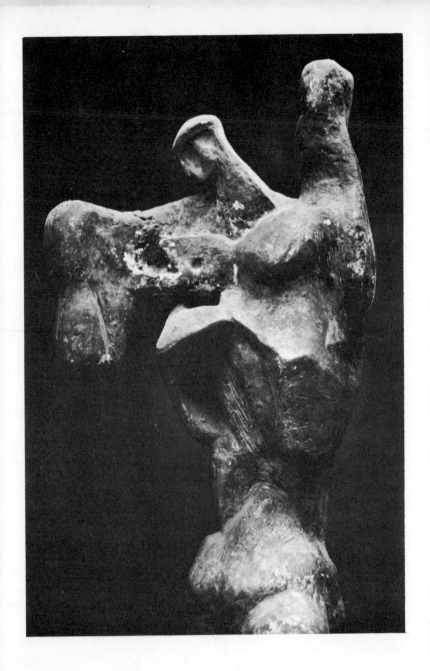

(Opposite) *Centaur's Torso*

Two-Headed Giant with Egg

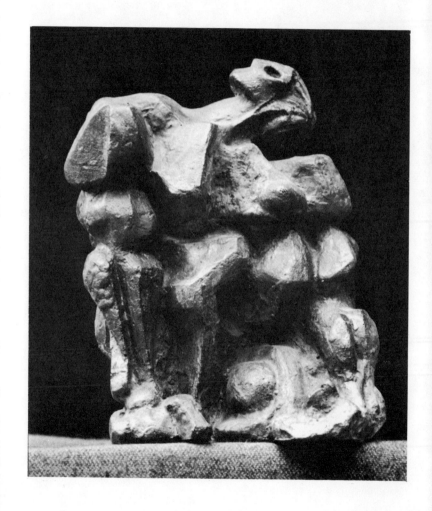

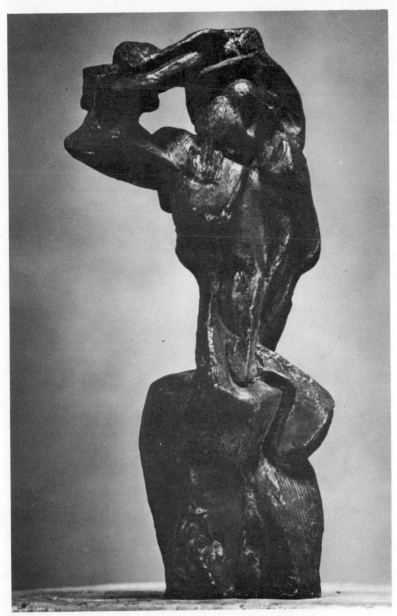

Figure with Another Sleeping Inside It

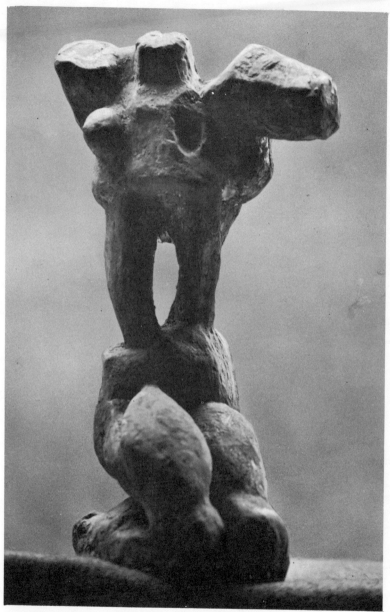

Hermaphrodite Torso

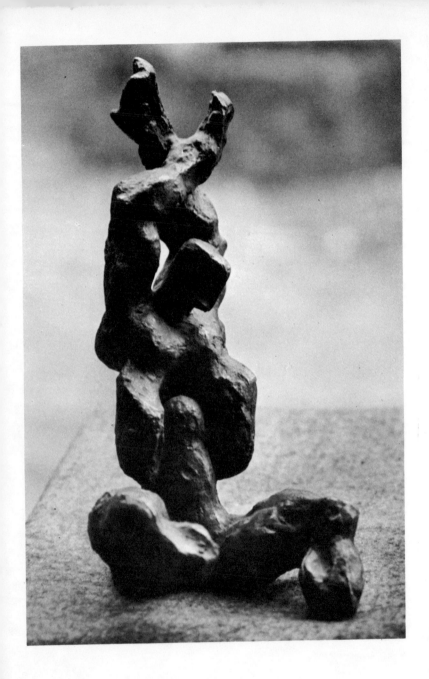

(Opposite) *Adam*

Figure with Child Sleeping Inside It

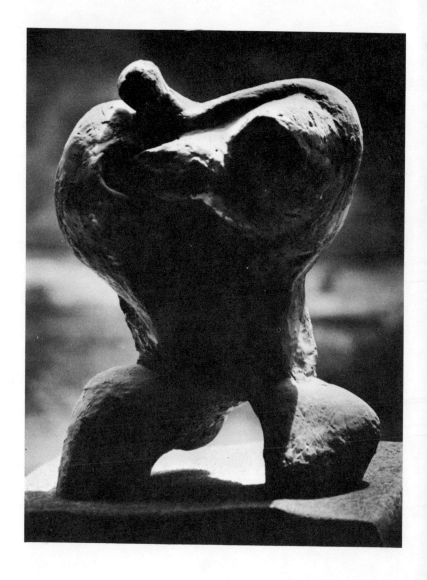

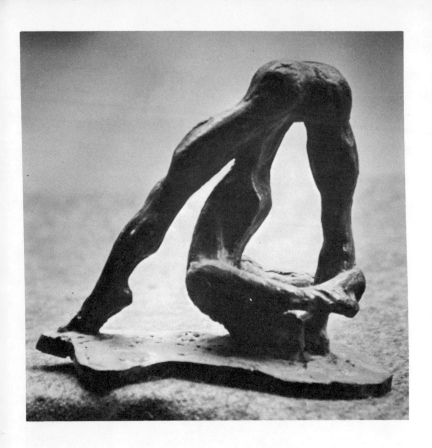

Antipode

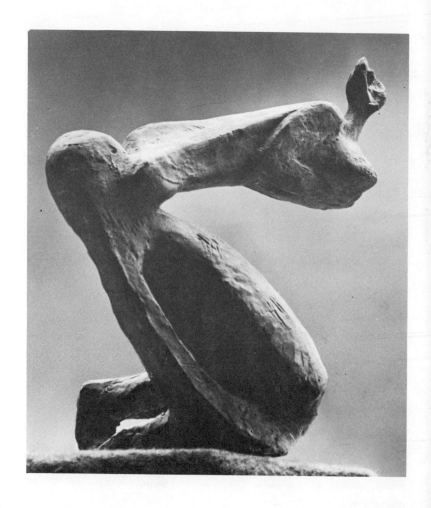

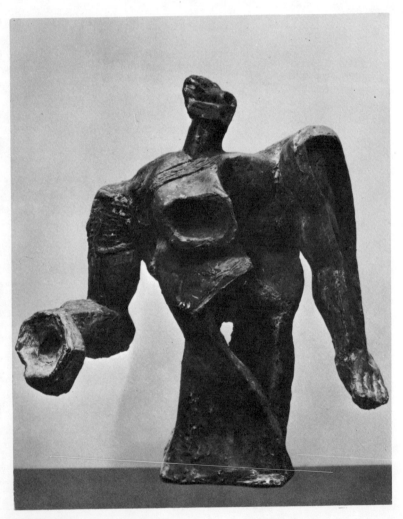

Machine Man

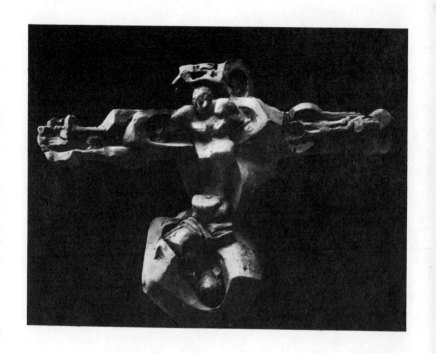

Crucifixion

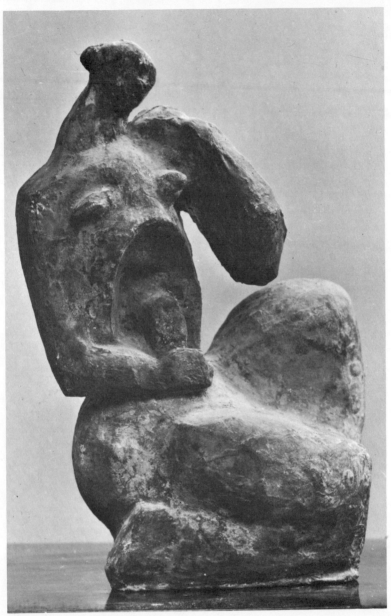

Neizvestny. *Woman and Foetus*. Bronze. 1961

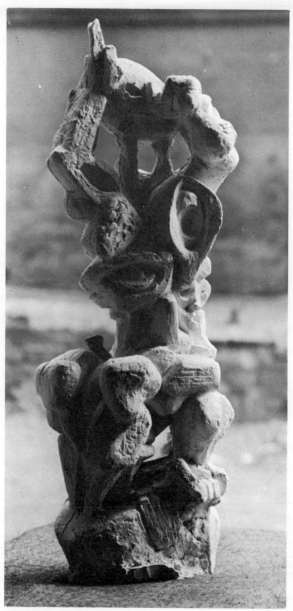

Construction of Man

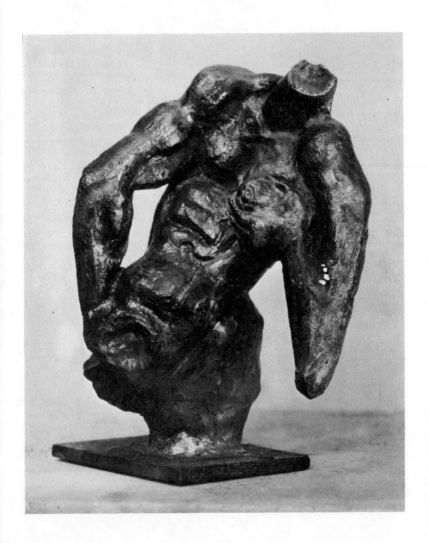

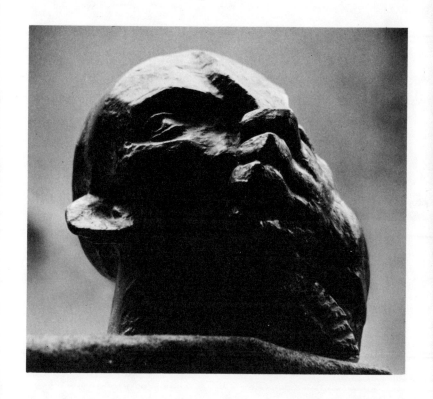

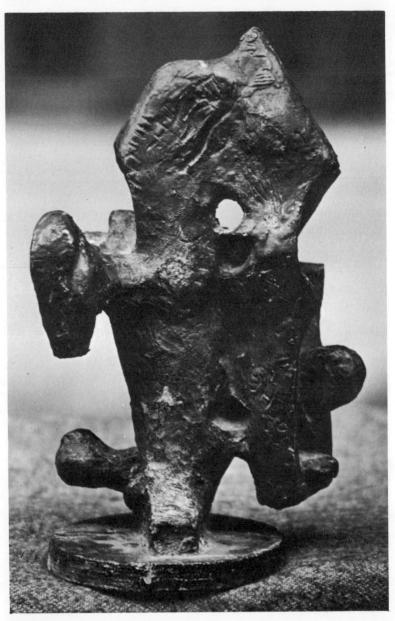

The Kiss

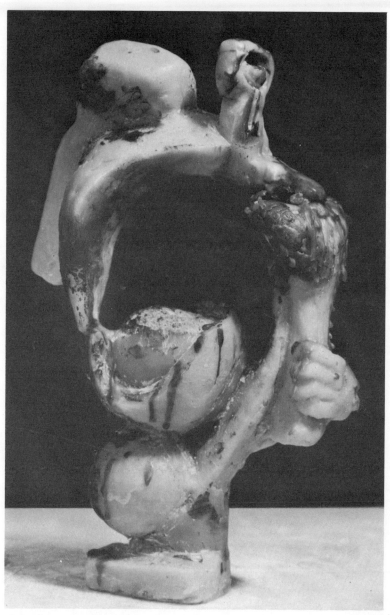

Two Spheres Inside One Another

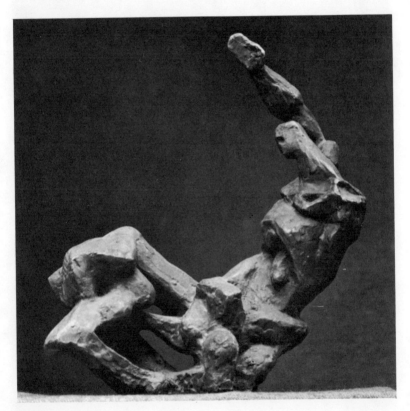

Centaur

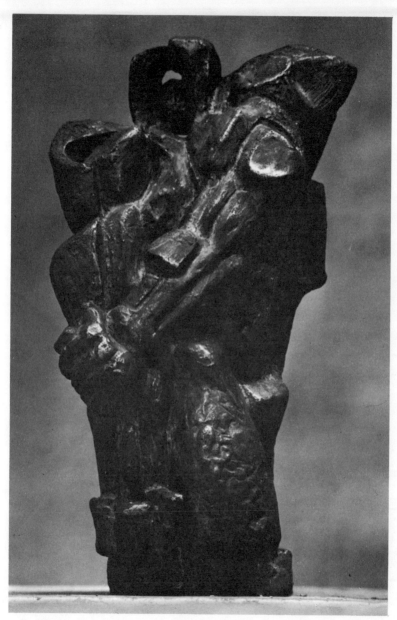

Giant's Torso

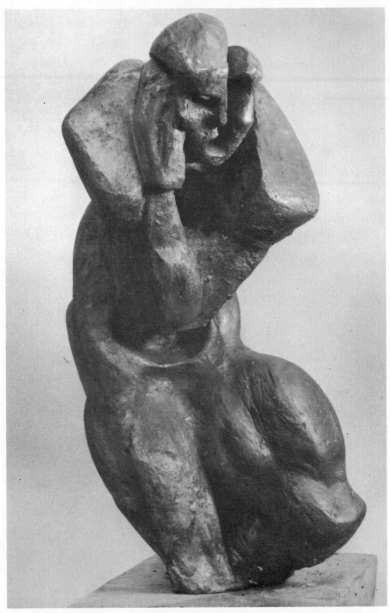

Man Restraining Himself

Index